MW00779387

Flags and Faces

THE FRANKLIN D. MURPHY LECTURE SERIES

David Cateforis, Series Editor (2014-)

Established in 1979 through the Kansas University Endowment Association in honor of former chancellor Dr. Franklin D. Murphy, the Murphy Lectureship in Art brings distinguished art historians, critics, and artists to the University of Kansas, where they participate in the teaching of a graduate seminar in the Kress Foundation Department of Art History and deliver two public lectures, one at the Spencer Museum of Art and one at the Nelson-Atkins Museum of Art, the published versions of which are presented in this series.

THE FRANKLIN D. MURPHY LECTURERS IN ART

1979	Pierre Rosenberg	1994	John Szarkowski
1980	Brian O'Doherty	1996	Karal Ann Marling
1981	Xia Nai	1996	John M. Rosenfield
1982	Richard Field	1998	Serafín Moralejo
1983	Robert G. Calkins	1999	Helmut Brinker
1983	Svetlana Alpers	2001	Yi Sŏng-mi
1984	Nubuo Tsuji	2001	Wanda M. Corn
1986	David Rosand	2003	Donald McCallum
1987	James Cahill	2004	Roberta Smith
1987	William Vaughan	2005	Tamar Garb
1988	Walter S. Gibson	2007	Okwui Enwezor
1989	Thomas Lawton	2008	David M. Lubin
1990	Johei Sasaki	2009	Christopher M. S. Johns
1992	Marilyn Aronberg Lavin and Irving Lavin	2010	Toshio Watanabe
		2012	Michael Brenson
1994	Lothar Ledderose	2014	Cynthia Hahn

Flags and Faces

The Visual Culture of
America's First World War

DAVID M. LUBIN

UNIVERSITY OF CALIFORNIA PRESS

in association with the Spencer Museum of Art
and Kress Foundation Department of Art History,
the University of Kansas

The publisher gratefully acknowledges the generous contributions to this book provided by the University of Kansas Provost's Office and the Franklin D. Murphy Lecture Fund through the Spencer Museum of Art and the Kress Foundation Department of Art History, the University of Kansas.

University of California Press, one of the most distinguished university presses in the United States, enriches lives around the world by advancing scholarship in the humanities, social sciences, and natural sciences. Its activities are supported by the UC Press Foundation and by philanthropic contributions from individuals and institutions. For more information, visit www.ucpress.edu.

University of California Press
Oakland, California

© 2015 by The Regents of the University of California

Library of Congress Cataloging-in-Publication Data

Lubin, David M., author.
 Flags and faces : the visual culture of America's First World War / by David M. Lubin.
 pages cm. — (Franklin D. Murphy lectures)
 Includes bibliographical references and index.
 ISBN 978-0-520-28363-3 (cloth : alk. paper)
 1. World War, 1914–1918—United States—In art. 2. World War, 1914–1918—Art and the war. 3. World War, 1914–1918—United States—Propaganda. 4. Visual communication—United States—History—20th century. 5. Popular culture—United States—History—20th century. 6. Art, American—20th century. 7. Symbolism—United States—History—20th century. I. Title.
 N9155.U6L83 2015
 701'.08—dc23 2014025478

Manufactured in China

24 23 22 21 20 19 18 17 16 15
10 9 8 7 6 5 4 3 2 1

The paper used in this publication meets the minimum requirements of ANSI/NISO Z39.48-1992 (R 2002) (*Permanence of Paper*).

For Sam Lubin (1917–2012)

CONTENTS

This small book puts into essay format the Franklin D. Murphy lectures in art that I gave at the University of Kansas in the spring of 2008. The lectures themselves grew out of the reading and writing I had already been engaged in for a couple of years concerning the diverse and sometimes antagonistic ways that artists, designers, and other makers of American visual culture responded to the catastrophic European war that pulled their nation into its vortex in the spring of 1917. The Murphy lectures provided an excellent opportunity to present my research to a broad-based audience of students, scholars, and the general public in Lawrence and Kansas City.

The essays are concerned with different but overlapping periods of time. Chapter 1, "Art for War's Sake," examines several of the ways that paintings and posters were used by preparedness advocates to drum up support for intervention by the United States in the war between the Allied Forces and the Central Powers. It also looks at oppositional art made by artists who rejected this push toward war. Chapter 2, "Fixing Faces," focuses on the postwar phase, when the country was inundated with veterans whose faces had been severely, sometimes irreparably, damaged in trench warfare. What

happened, it asks, when these men returned from the front, looking nothing like the idealized heroes of the recruitment posters or, in some instances, not even recognizably like men?

While one chapter concentrates on art designed for or against participation in the war and the other contemplates medical, artistic, and cultural responses to disfigurement, they have a common theme, which might loosely be subsumed under the umbrella term *gender anxiety*. The posters and paintings made by interventionists invoked old-fashioned, chivalric codes that essentially defined manhood as a state of readiness to safeguard women from intruders. These brightly colored, dramatically composed vignettes implied—sometimes subtly, sometimes not—that a man who hesitated to sacrifice his life for his nation and its womenfolk was not truly a man. Concerns about failed masculinity were also at stake with the men who suffered severe facial trauma or other types of permanent and conspicuous physical damage. Their suffering, no doubt, was made worse by the conventional depictions of square-jawed masculinity with which poster designers, magazine illustrators, and Hollywood filmmakers had filled their heads before, during, and after the war. No one could live up to these standards, men with shattered faces least of all.

In the opening essay, women play a passive role; all the art I consider was made by male artists, and when women are depicted, it is to be shown as actual or potential victims of enemy aggression. In "Fixing Faces," however, they have a more active presence. One of the key figures I discuss is Anna Coleman Ladd, a sculptor who conceived and directed the American Red Cross Studio for Portrait Masks in Paris, which custom-fitted facially mutilated soldiers with prosthetic masks that allowed them to be seen in public without causing onlookers to recoil from the unsightliness of their wounds. Helena Rubinstein, the makeup entrepreneur, and Greta Garbo, the legendary beauty goddess of the silver screen, also appear in the essay as active agents of cultural transformation. But women more generally occupy a cen-

tral place in the discussion, for I contend that cosmetic surgery and pros-
thetic masking, expediencies devised for the benefit of *men* during the war,
were marketed afterward to a consumer base consisting mostly of *women*.

The book's two chapters are interdisciplinary in nature. Limited in scope
but wide-ranging in content, they examine multiple forms of visual media:
paintings, posters, photographs, cartoons, sheet music covers, and flags in
the first; plastic surgery, prosthetic sculpture, medical illustration, atroc-
ity photography, modern art, beauty makeup, and star acting in the second.
The purpose of this gallop through the visual environment of the day is to
see how a variety of talented artists and artisans used their special skills to
envision war and homeland for the public in the one instance and to remake
imperfect faces in the other.

The long and murderous twentieth century demonstrated this: that
democratic populations cannot go to war, stay at war, and remember—or
forget—war without the aid of powerful visual representations. Some of
these representations, emerging from government agencies, speak directly
to matters at hand and are called propaganda. More often, however, these
representations spring from sources in art, entertainment, advertising, and
daily life, and they are often indirect in what they have to say about war.
That makes them more effective than bald-faced propaganda in motivating
viewers. This book examines America's first great effulgence of war-related
visual culture, which flourished during a fifteen-year stretch, from roughly
the sinking of the *Lusitania* in 1915 through the ending of the war in 1918 to
the crashing of Wall Street in 1929.

+ + + +

I wish to thank the members of the Kress Foundation Department of Art
History at the University of Kansas for honoring me with their invitation to
deliver the Murphy lectures. Professors David Cateforis and Charles Eldredge
were kind and generous hosts for my two, week-long visits to Lawrence as

the Murphy lecturer. I enjoyed the privilege of working closely with the fourteen graduate students enrolled in the seminar on American art that David and Charlie organized that semester. I am grateful as well for the support of Professor Linda Stone-Ferrier, chair of the department, Saralyn Reece Hardy, director of the university's Spencer Museum of Art, colleagues with whom I shared productive discussions during my residencies, and the department's invaluable office manager, the late Maud Humphrey.

I began work on this project under the auspices of Harvard University's Warren Center for the Study of American History and completed it while in residence at the National Gallery of Art's Center for Advanced Studies in the Visual Arts. I would like to thank both of these research centers, as well as my home institution, Wake Forest University, for the encouragement and support they provided.

Finally, special thanks to two of my former students. Sarah Pirovitz helped me convert the Murphy lectures into the chapters before you, and Laura Minton displayed abundant organizational skills and a spirited sense of humor in obtaining the images reproduced in the following pages.

Art for War's Sake

Within a month of declaring war on Germany in April 1917, the US government set in motion a two-pronged effort to control the nation's production and consumption of war-related visual materials. On one side of the equation was George Creel, a liberal Kansas newspaper editor and former investigative journalist with dashing good looks and abundant Midwestern charm. President Wilson named him head of the new Committee on Public Information—America's official propaganda agency. His organization, widely known as the Creel Committee, commissioned thousands of paintings, posters, sculptures, cartoons, and illustrated lectures to engage Americans in the war effort. Creel titled his account of the wartime enterprise *How We Advertised America* (1920) and, indeed, he and the many artists he enlisted viewed their endeavor as an exercise in collective salesmanship.[1]

Creel's counterpart on the darker side of information management was Postmaster General Albert S. Burleson, a reactionary from Texas whose father had served as an officer in the Confederacy. In his appointed role as guardian of the mails, Burleson diligently obstructed the flow of radical periodicals and pamphlets through the postal system. He used a variety of judicially approved law enforcement procedures, including secret surveillance, police raids, and prolonged pre-trial incarceration, to intimidate and harass left-wing editors and artists so they would not circulate antiwar imagery.[2]

Many prominent Americans, including the millionaire automobile man-

ufacturer Henry Ford, the statesman William Jennings Bryan, the author-lecturer Helen Keller, and the newspaper magnate William Randolph Hearst, had opposed military involvement in the Great War. Editorial cartoons in Hearst papers mocked the so-called warmongers and profiteers. Hearst's employee Winsor McCay, then the highest-paid editorial cartoonist in America, had to work on his own time on his anti-German diatribe, a pioneering animated film called *The Sinking of the "Lusitania"* (1918), because his boss vehemently opposed intervention. In December 1915, Ford, one of the wealthiest men in America, went so far as to charter an ocean liner to take him and a group of fellow pacifists to Europe in a well-publicized effort to promote peace and empty out the trenches by Christmas. The press mocked the expedition as "the ship of fools," infighting broke out among the participants, and Ford, suffering from influenza and admitting the naïveté of the mission, threw up his hands and booked passage home four days after landing in Oslo.[3]

Despite such efforts from rich, famous, and influential opponents to American intervention in the Great War, American visual culture, both popular and elite, was dominated by pro-intervention imagery. As early as September 25, 1914, New York artists formed the American Artists' Committee of One Hundred, which organized an exhibition and sale of paintings and sculpture to provide a relief fund for the families of French soldier-artists; by May 1917, the organization had 170 members in thirty cities across the nation. In 1916, the best known of these artists, an impressionist named Childe Hassam, embarked on a series of patriotic paintings that over the course of three years would result in some thirty canvases depicting New York City adorned with high-flying American flags.[4] This chapter examines one such painting in particular.

Along the way, we will contrast it with a now-iconic photograph from 1915 by Hassam's younger contemporary Paul Strand that seems in every way the painting's opposite. Beyond obvious differences in visual medium

and aesthetic outlook (the painting is impressionist in a derivative, almost academic manner, the photograph modernist), they also differ in their attitude toward the European war. Hassam's painting embraces and seeks to justify American involvement in the war, whereas Strand's photo, though much less overt than the painting in its political tenor, represents the left's critical opposition to the war.

Until the spring of 1917, when unfolding events changed their minds, most Americans opposed entering the European conflict, but the visual record of the era contains surprisingly little evidence of this opposition. Most of it came from farmers, industrial workers, and ethnic-immigrant groups, especially German Americans and Irish Americans, who former president Theodore Roosevelt disparagingly called "hyphenated Americans." For the most part, these sizable and significant subsets of the larger population did not avail themselves of visual means of communication to represent their anti-intervention point of view. In those days, the main conduits for visual imagery in America—theatre, publishing, advertising, the fine arts, and the movies—were dominated by individuals or families who were proud of their Anglo-Saxon heritage (or, if lacking it, as was often the case in the film industry, made all the more effort to mimic and flaunt it). This discrepancy in control of the media explains why interventionist art was far more plentifully produced and disseminated than the anti-interventionist variety.

The radical socialist magazine the *Masses*, edited by Max Eastman and Floyd Dell, was one of the only consistent sources of antiwar, antimilitary visual imagery. The urban-scene painter and illustrator John Sloan served as the periodical's art editor from 1913 to 1916, until he had a falling out with Eastman, who insisted that the editorial cartoons be more didactic and text-driven than Sloan preferred. Sloan wanted the images to tell their own story without heavy-handed captions, and when he resigned in protest, he was joined by several, though not all, of the magazine's best-known political illustrators. Still, both before and after Sloan's departure, the magazine fre-

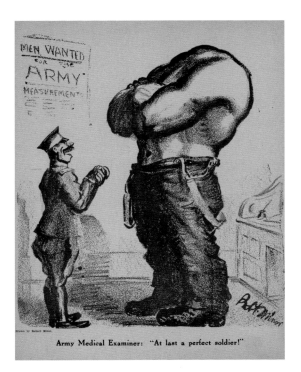

Figure 1.
Robert Minor, "At
Last a Perfect Soldier!"
(Masses, July 1916).

quently featured acerbic antiwar images. For example, Robert Minor's satir-ical cartoon "At Last a Perfect Soldier!," published in 1916, shows a medical examiner rubbing his hands in gleeful admiration of a gigantic, headless, bare-chested recruit, literally all brawn and no brain (Fig. 1).[5]

When Congress declared war and made antiwar speech (and art) illegal under the Espionage Act of 1917, the Masses ran afoul of censors. Postmas-ter General Burleson sought to shut down the magazine. His office with-held second-class mailing privileges, which made the cost of circulation by subscription prohibitive. News dealers, concerned to stay on the right side of the law, refused to sell the magazine. In November 1917, the government indicted the editors and owners of the periodical on the grounds that it had

Art for War's Sake

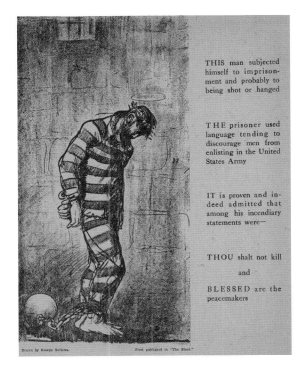

THIS man subjected
himself to imprison-
ment and probably to
being shot or hanged

THE prisoner used
language tending to
discourage men from
enlisting in the United
States Army

IT is proven and in-
deed admitted that
among his incendiary
statements were—

THOU shalt not kill

and

BLESSED are the
peacemakers

Drawn by George Bellows. First published in "The Blast."

Figure 2.
George Bellows, *"Blessed are the Peacemakers"* (*Masses*, July 1917).

obstructed enlistment. One of the offending images was by George Bellows, a frequent contributor of satirical drawings to the *Masses* and other left-wing periodicals (Fig. 2). The cartoon shows Jesus in prison. Manacled, clad in stripes, bound by ball and chain, the Prince of Peace has been incarcerated for preaching the seditious words "Thou shalt not kill" during wartime.[6]

Even more inflammatory was Henry Glintenkamp's drawing of a skeleton measuring a naked young recruit for his coffin. This was indeed a direct assault on enlistment, and Glintenkamp was named in the indictment. He fled to Mexico to avoid trial. The following year, a split jury acquitted Eastman and his co-defendants, but by then the *Masses* had gone out of business, unable to withstand the combined costs of legal fees and first-class mailing rates.

+ + + +

It is against this backdrop of thwarted antiwar activism that we turn to the patriotic flag paintings of Childe Hassam. Rather than skimming across a handful of the thirty he produced, let us focus on one that is in many ways representative, *Early Morning on the Avenue in May 1917* (Fig. 3). This sunny tableau commemorates the dawn—or, if you will, the early morning—of American involvement in the First World War. It depicts Fifth Avenue pedestrians, mostly women, promenading beneath a canopy of flags representing the Allied nations England, France, Italy, Belgium, and, most prominently, the United States of America, which had joined the Allied forces only a month earlier, with its declaration of war.

Together, the flags direct the viewer's eye to the busy thoroughfare thronged with pedestrians and motor buses. Hassam did not invent these flags and impose them on the composition for aesthetic reasons alone. They actually festooned Fifth Avenue in mid-May 1917, when he made the painting. They flew from the walls and rooftops of the avenue, as well as many other parts of the city, in a civic greeting that New Yorkers orchestrated for Allied war commissioners, who were passing through the city to bolster enthusiasm for the Allied cause.[7]

Stillness pervades the picture. Aside from the flags, which flutter in the breeze, almost nothing moves. The back foot of the delivery man crossing the street rises from the pavement, but otherwise stasis prevails. Pedestrians seem frozen in place, as if by the chalky white ambience that glazes the image, but also by their attire, which emphasizes length and physical compactness. Heads extended upward by fashionable millinery, arms downward to their calf-length skirts, the women occupy space vertically but do not cross it horizontally.

Architecture dominates the setting, as seen from the intersection of Fifth Avenue and 54th Street: the chunky white blocks of St. Thomas's Epis-

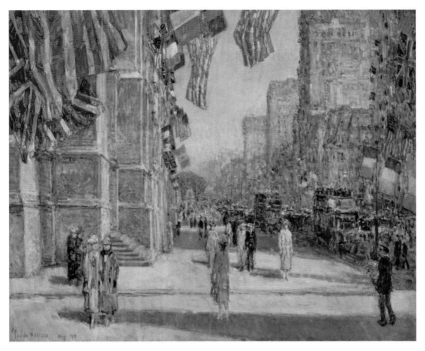

Figure 3. Childe Hassam, *Early Morning on the Avenue in May 1917*, 1917. Oil on canvas, 30¹/₁₆ × 36¹/₁₆ in. (76.36 × 96.1 cm). Addison Gallery of American Art, Phillips Academy, Andover, Massachusetts.

copal Church at left, the cliff-like recession of lofty office towers or hotels at right. The image as a whole is geometric, an orderly array of rectangular slabs constituted by buildings, conveyances, and pedestrians alike, neatly spaced on a grid, with only the dancing flags, the patch of opalescent blue sky, and a few diagonal shadows interrupting the vertical regularity of the serenely static world portrayed. The flags bring the city to life, imparting sanguine warmth to its otherwise cool, early morning pallor.

For contrast, we might look at a street scene by Bellows, who was Hassam's opposite. A generation younger, trained in New York rather than Paris,

Art for War's Sake

and deeply committed to left-wing politics, Bellows disdained the genteel tradition that the older artist exemplified. His paintings of urban life, such as *New York* (1911, National Gallery of Art), are dense with crowds, thick with pigment, laden with atmosphere. The paint handling is rough, muscular, and abrasive, like the mean streets depicted. Bellows insists on the polyglot, heterogeneous, multiclass, multiethnic, multilayered nature of New York and, by extension, America itself, while Hassam celebrates unity, homogeneity, metropolitan rationality, and civic order. Indeed, *Early Morning on the Avenue* could even be understood as a riposte to Bellows's painting *Cliff Dwellers* of 1913, where the laundry of immigrants from around the world, not the ceremonial flags of preferred nations, flutters and flies over the heads of pedestrians (Fig. 4).

The red, white, and blue color scheme of Hassam's painting is no accident. Attesting to the fervor of the moment in history when the United States shrugged off its long-standing policy of political isolation and leapt onto the world stage, the painting conflates flags, femininity, commercial culture, and religious worship to remind viewers of the democratic values that they were supposedly going to war to defend. A passionate supporter of the Allies, Hassam was elated by his nation's abandonment of neutrality. Like many American painters who had trained in France (in his instance, several decades earlier), he nursed a sentimental attachment to the land of his artistic apprenticeship.

Hassam was also an Anglophile, proud of his English ancestry and New England upbringing, which he repeatedly referred to with his iconic series of paintings of a New England country church. Although his surname Hassam (which he pronounced *HASS-em*) struck his contemporaries as vaguely Middle Eastern, he made a point of noting it was completely English in derivation. He liked to joke about his descent "from that pure Arabian stock that landed in Dorchester [Massachusetts] in 1631."[8] In *Early Morning on the Avenue* he expressed his American patriotism, his Francophilia, and his Anglo-

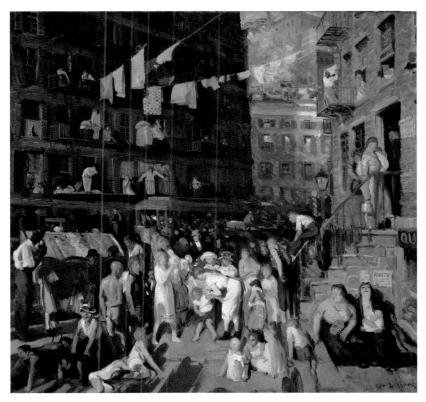

Figure 4. George Bellows, *Cliff Dwellers*, 1913. Oil on canvas, 40³/₁₆ × 42¹/₁₆ in. (102.07 × 106.83 cm). Los Angeles County Museum of Art.

philia, while exploring the chromatic effects of light in modern urban settings, his long-standing impressionist agenda.

Hassam's flag paintings constitute his last significant body of work. They pay homage to the theme-and-variation method of Claude Monet, the French master he most revered, who serially painted haystacks, cathedral fronts, and water lilies. More specifically, Hassam's flag paintings allude to

Art for War's Sake

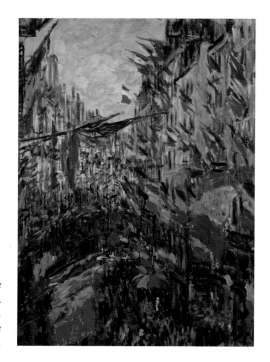

Figure 5. Claude Monet, *Rue Saint-Denis, fête du 30 juin 1878*, 1878. Oil on canvas, 28½ × 20⅝ in. (73.5 × 52.5 cm). Museum of Fine Arts, Rouen.

works by Monet such as *Garden at Saint-Adresse* (1867, Metropolitan Museum of Art), where two pennants, one nautical, the other national, snap in the seaside breeze, or, even more apt, *Rue Saint-Denis, fête du 30 juin 1878*, in which myriad French tricolors spring from the windows and walls of Parisian buildings in a frenzy of brushwork that proclaims the democratic energy of the French Third Republic.

A handful of Hassam's flag paintings strive for the delirium of Monet's *Rue Saint-Denis;* among them are *Allies Day, May 1917* (Fig. 6) and *Red Cross Drive, May 1918 (Celebration Day)*. But most of his flag paintings are too circumspect to let loose with such a daring farrago of light, color, and nation-

Art for War's Sake

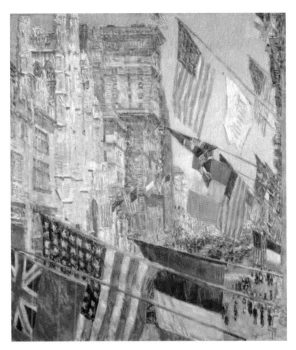

Figure 6. Childe Hassam, *Allies Day, May 1917*, 1917. Oil on canvas, 36½ × 30¼ in. (92 × 76.8 cm). National Gallery of Art.

alistic intensity. None is more orderly, tranquil, and still than *Early Morning on the Avenue*, with its almost Euclidean geometry, in which flat patches of crimson, representing the flags, rhythmically punctuate the bluish-white recession into space.

Hassam was no artistic innovator. There was nothing controversial about his complacent impressionism, in which the armature of solid geometric form holds light's flickering transience securely in check. For years, if not decades, impressionist technique had been assimilated into American art, so if anything about Hassam's flag paintings struck his contemporaries

Art for War's Sake

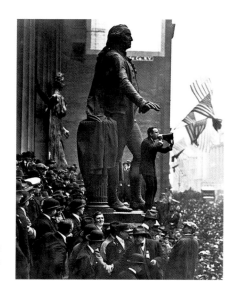

Figure 7. Douglas Fairbanks
at Liberty Loan Rally, 1918
(Paul Thompson, photographer).

as controversial, it was their ardent support of military intervention. Fine art, unlike its lower-status cousin graphic illustration, was not supposed to express a manifestly political point of view. Moreover, many Americans opposed intervention during the buildup to war and even, for a time, after the declaration of war itself.[9]

Though outraged by the *Lusitania* atrocity in May 1915, most seem to have regarded it as an unfortunate instance of what today we call collateral damage. Invoking George Washington's venerable advice to his country-men not to become entangled in foreign embroilments, they rejected mili-tary engagement abroad and in November 1916 reelected the peace candi-date Woodrow Wilson, who campaigned on the slogan "He kept us out of war." Once the United States entered the war, however, even Washington, the Father of His Country, blessed the endeavor, as suggested in a photo of the actor Douglas Fairbanks addressing a crowd at a war-bond rally on Wall

Street. The general's statue appears to be bestowing a benediction, or even patting the patriotic movie star on the head (Fig. 7).

+ + + +

Hassam painted as a champion of the preparedness movement. Preparedness advocates urged the government to build up American armed forces and ordnance to unprecedented levels so that the country could respond instantly and powerfully when the call to war came, as surely it would. They sought every means to achieve their goal, and that included sponsoring elaborate Preparedness Day parades in cities across America.

Although the business leaders and Chamber of Commerce representatives who organized these large public events claimed their interest was to foster national unity, the parades themselves aroused fierce class antagonisms. Labor leaders contended that preparedness did not help nations achieve peace but rather pushed them toward war, as was evident from the current conflagration in Europe. "A country which carries a large standing army and navy is like a school boy with a chip on his shoulder, always courting trouble," a spokesman for the machinists union warned, adding: "If the masters of the country want preparedness let them go to war, but let the working class prepare their unions so that they will not be led into slaughter as their brothers in Europe have been." A representative of the musicians union observed that "preparing for war to insure peace is about as logical as to saturate wood in oil to protect against fire; preparing for war means war."[10] Labor leaders argued that under all the patriotic bluster, the real reason for going to war was to line the pockets of the bosses, cut wages, and deprive workers of their rights to collective bargaining.

In July 1916 a suitcase bomb exploded at a Preparedness Day parade in San Francisco. Ten bystanders were killed and another forty wounded. The radical union organizers Tom Mooney and Warren Billings were hastily convicted of the crime. Mooney received a death sentence, which was later

commuted to life in prison, though commentators on the left argued vehe-
mently, and to this day many historians believe, that both men had been
framed and that agent provocateurs had ignited the bomb.[11]

Henry L. Stimson, formerly secretary of war under Theodore Roosevelt,
was a leading figure in the preparedness movement. In 1916 Stimson, along
with others, including Roosevelt and J. Pierpont Morgan, Jr. (son and succes-
sor of the banking titan, who died in 1913), organized the National Defense
League, a coalition of financiers, industrialists, corporate heads, and politi-
cians dedicated to heightening America's military prowess. When the nation
finally did go to war, Stimson went along with it, as an artillery officer sta-
tioned in France, though he was dissatisfied to find himself some distance
from the front.

Stimson's older sister Alice purchased *Early Morning on the Avenue* in 1930,
intending to bequeath it in her brother's honor to Phillips Andover Academy,
his alma mater. When Hassam's work finally entered the school's art collec-
tion in 1944, Stimson was again serving as secretary of war, this time under
Franklin Roosevelt and his successor, Harry Truman. Perhaps Stimson,
more than any other figure, can be regarded as the architect of the modern
national security state or, as the sociologist Harold Lasswell called it in 1942,
the garrison state, in which ongoing preparedness for war displaced the
nation's broader concern for democratic openness and transparency.[12] Stim-
son's top project as war secretary was the development of nuclear weapons.
In the summer of 1945, despite clear indications that Japan teetered on the
verge of collapse, Stimson campaigned tenaciously, and at last successfully,
to overcome the president's reluctance to drop the atomic bomb without
warning on Hiroshima and Nagasaki.[13]

It is easy to imagine what Henry Stimson would have liked about *Early
Morning on the Avenue*. Portraying his beloved New York City in pristine light,
with a Protestant church and Allied flags lofting protectively over its wom-
enfolk, it must have reinforced his desire to defend the homeland at any

Art for War's Sake

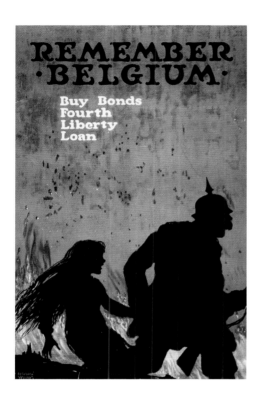

Figure 8. Ellsworth Young, *Remember Belgium—Buy Bonds—Fourth Liberty Loan*, 1918. Library of Congress.

cost. The prominence of the women in the painting is noteworthy. Picturing white, middle-class women implicitly or explicitly endangered by the barbarism of the enemy helped to sell the war to a public initially reluctant to take arms.

The melodramatic motif of the violated virgin appeared in numerous recruitment posters after America entered the war.[14] Ellsworth Young's *Remember Belgium* shows a middle-aged, spike-helmeted Hun, a phallic firearm conspicuously poised between his legs, dragging a reluctant female child by the hand, both of them silhouetted against a flaming sky (Fig. 8). Another poster, Louis Raemaekers' *Enlist in the Navy* (ca. 1917, Library of Con-

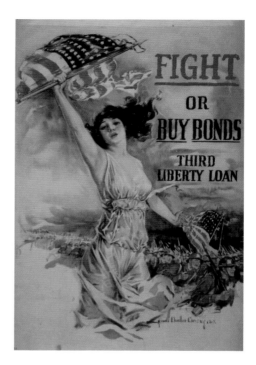

Figure 9. Howard Chandler
Christy, *Fight or Buy Bonds—
Third Liberty Loan*, 1917.
Library of Congress.

gress), pictures Uncle Sam in military garb pointing a revolver at a whip-
wielding Kaiser, who is about to ravage a maiden chained to an overturned
cross. Still another poster, produced by the American Association of Motion
Picture Advertisers and signed by an artist named Schneck (ca. 1917, Library
of Congress), depicts Uncle Sam hovering in dismay over the violated body
of his daughter, the red stripes of the American flag gushing from her lap like
blood: "It's up to you" admonishes the text. "Protect the nation's honor—
enlist now."

Patriotic posters used the flag as a means of associating threats to Ameri-
can virginity with the defilement of national purity. Particularly notewor-
thy in this regard were posters designed by the Anglo-Saxon old-guard tri-

umvirate Howard Chandler Christy, Harrison Fisher, and the aptly named James Montgomery Flagg, whose poster *I Want You for the U.S. Army* is perhaps the single best-known, most universally recognized artifact of the First World War. The flag of the United States serves frequently in their work as a lavish adornment for the fine-boned, delicately featured WASP femininity that they liked to purvey as the allegorical symbol for America. Even when leading American troops into imaginary battle, these allegorical figures were dainty, softly contoured, long-lashed female beauties, as in Christy's famous *Fight or Buy Bonds* poster (Fig. 9), modeled on Eugène Delacroix's rousing revolutionary tableau from 1830, *Liberty Leading the People*. These artists belonged to the same social set and cultural milieu as both Henry Stimson and Childe Hassam. Rather than feature pretty maidens wrapped in Old Glory, Hassam's flag paintings limit themselves to surveying from afar the white, upper-class enclaves of New York, populated by faceless stick figures. Still, they benignly associate beauty, purity, Puritan lineage, and patriotism. As one of Hassam's admirers wrote shortly after the war, "He made the Flags symbolic of his heritage. Only a Puritan could have painted flags as he did."[15]

+ + + +

Recruitment and Liberty Loan posters were not alone in flooding popular culture with gender-based appeals for enlistment and other forms of patriotic support. The sheet music and recording industries made similar appeals; for instance, following the initial popularity of the 1915 pacifist song "I Didn't Raise My Boy to Be a Soldier," there were plenty of anti-pacifist parodies, among them "I Didn't Raise My Boy to Be a Coward," "I Didn't Raise My Boy to Be a Slacker," and "I'm Going to Raise My Boy to Be a Soldier and a Credit to the U.S.A." George M. Cohan's "Over There," the most popular war song of the era, explicitly appealed to conventional sex-role expectations. Before the fighting was "over, Over There," hundreds of thousands

Art for War's Sake

of recordings sold, as well as more than two million copies of sheet music. "Johnnie, get your gun, get your gun, get your gun," the singer implores. "Hurry right away, no delay, go today. / Make your daddy glad / To have had such a lad. / Tell your sweetheart not to pine, / To be proud her boy's in line."

Undoubtedly, the great fame and lasting appeal of the song have less to do with its masculinity-affirming lyrics—which, to be sure, are not unimportant—than its rousing chorus, which takes an agitated and insistent three-note bugle call ("Send the word, Send the word, Over there") and resolves it rapturously, "That the Yanks are coming, The Yanks are coming . . . / And we won't come back till it's over, Over There." Four successive editions of the sheet music were published in the United States and England in 1917 and 1918. One of these used a cover illustration by the young, relatively unknown graphic artist Norman Rockwell, whose first of what amounted to several hundred *Saturday Evening Post* covers had appeared in 1916. His sheet music cover for "Over There," originally published as the cover illustration of a humor magazine, shows four fresh-faced, practically juvenile doughboys singing, strumming a banjo, and merrily snapping their fingers. They gather around a campfire like Boy Scouts on a weekend retreat. Cohan's other most famous tune, composed for his 1906 Broadway musical *George Washington, Jr.,* was "You're a Grand Old Flag." This was the first Broadway song in history to sell over a million copies of sheet music, and it was recorded many times. The song's catchy chorus is irrepressible: "You're a grand old flag, / You're a high flying flag / . . . the emblem of / The land I love, / The home of the free and the brave."[16]

The flag paintings of Childe Hassam could not compare in popular appeal with the "flagophilia" of Cohan's beloved song, but the paintings, like the song, participated in a concerted effort in the late nineteenth and early twentieth centuries to sanctify the flag. Originally it did not enjoy that status. It appears to have been designed for the Continental Congress in the late 1770s by a New Jersey lawyer, poet, and signer of the Declaration of Indepen-

dence, Samuel Hopkinson, who asked to be remunerated for his efforts by "a Quarter Cask of the public wine." Francis Scott Key wrote his famous ode, "The Star-Spangled Banner," during the War of 1812, and politicians began exploiting the flag for campaign purposes in the 1840s, but it was not until Secessionists pulled down the Stars and Stripes at Fort Sumter in 1861 that it gained widespread currency, in the North at least, as America's ultimate rallying symbol.

During the last quarter of the nineteenth century and first of the twentieth, powerful veterans' lobbies such as the Grand Army of the Republic and exclusionary patriotic societies such as the Daughters of the American Revolution urged Congress to declare Flag Day a national holiday and make "The Star-Spangled Banner" the national anthem (it only officially became so in 1931). The Pledge of Allegiance was written in 1892 with the intent of instilling patriotic ardor in the hearts and minds of children and immigrants, two groups of individuals in whom patriotism was not presumed to be innate.

In the late nineteenth century, bills were introduced in Congress to protect the flag. The target for this legislation was not political protesters (who at that time did not see an advantage to be gained or point to be made by desecrating the flag) but commercial retailers, who had discovered that flying the flag in advertisements and window displays was an effective way to peddle merchandise. The bill failed because members of Congress worried that it would prohibit them from using the flag themselves in their reelection campaigns. Flag protection acts were put forward again at the start of the twentieth century, but by now the target had shifted from advertisers to protesters. Indeed, anarchists, socialists, and labor activists sometimes literally ripped or burned the flag as a form of dissent. Showing respect or disrespect for the flag became an expression of one's viewpoint about the country as governed.

In 1915, for example, a socialist clergyman contended that the flag "is a symbol that is used today chiefly to fool the voters and to whoop-it-up for

patriotism. Men will lay down their lives to preserve that symbol without considering in the least what those who wave that flag really stand for." He adds, "Capitalist politicians are trying to blindfold the eyes of workingmen with our flag, while the capitalists pick your pockets and exploit you."[17]

The anarchist Emma Goldman agreed, arguing that business, church, and government leaders were stirring up "flag mania" to divert workers and immigrants from their own continued exploitation. A cartoon in the April 1916 number of the *Masses* showed a clergyman, a politician, and a business-man cloaked in the flag as they stride arm-in-arm over a pile of dead soldiers; the man of God seems sorrowful but no more ready to renounce his patriotic covering than the others wrapped with him in Old Glory. (Maurice Becker, who drew the cartoon, declared himself a conscientious objector when the United States went to war the following year and decamped to Mexico; on his return in 1919 he was tried on charges of draft evasion, convicted, and sentenced to twenty-five years of hard labor in Leavenworth Prison, where he served four months before receiving a pardon.) By the time Hassam painted *Early Morning on the Avenue*, the flag was disliked by a sizable minority of the American population as intensely as it was revered by those in the majority.[18]

Occasionally the Stars and Stripes served as a symbolic prop in the public violence staged by vigilantes who sought to intimidate and humiliate foreign-born, radical, or working-class individuals whom they deemed insufficiently patriotic. The most egregious instance occurred in April 1918, when a mob in southern Illinois wrapped a German-born union activist, Robert Prager, in a large American flag and forced him to march up and down the street waving and kissing smaller flags before they hanged him from a tree. When the leaders of the lynch party were subsequently tried and acquitted of murder charges by a jury of their peers, a local band celebrated by striking up "The Star-Spangled Banner," "Over There," and other flag-waving tunes.[19]

Art for War's Sake

Anti-German sentiment was not always so violent. More typical was the renaming of sauerkraut "liberty cabbage," frankfurters "liberty dogs," and hamburgers "liberty steaks." Still, the mood was ugly and grew uglier as the war progressed and the number of American casualties mounted.

Flags, ubiquitous in American visual culture during the war years, became, as never before, potent signifiers, capable of arousing, on sight, intense emotions, among them patriotic fervor, jingoist pride, anarchist disgust, and vigilante hate. They served as visual weapons par excellence. To be sure, saturating the visual landscape with symbolically charged colored cloth to stir nationalist loyalties was not a phenomenon unique to the United States. Men everywhere were willing to kill for their country's flag and, if need be, die for it.

The British historian W. J. Gordon observed in 1915, "Symbols are sacred things: and one of the chief that every man holds dear is the national flag. Deep down in our nature is the strong emotion that swells the heart and brings the tear and makes us follow the flag and die round it rather than let it fall into the hands of the enemy."[20] On the home front as well as on the battlefield, it resonated deeply with viewers and stirred overwhelming passions.

+ + + +

Occasionally Paul Strand, a brash young photographer with avid ties to the American left, ventured with his camera into Childe Hassam's uptown world. His 1915 photograph *Fifth Avenue* is one of his sprightliest images (Fig. 10). Composed on the vertical axis, it shows the spires of St. Patrick's cathedral piercing the gray tonality of the sky, while, at the bottom edge of the photo, opposite the cathedral and distinct from the crowd, three young women in stylishly decorated millinery stroll shoulder-to-shoulder beneath an angled flagpole, from which an American flag curves into the shape of a crescent. Two of these women look back at the photographer, as if from curi-

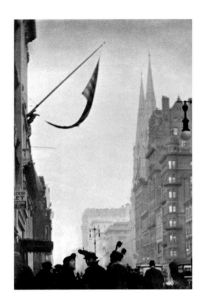

Figure 10. Paul Strand, *Fifth Avenue, New York*, 1915. Platinum print, 12¼ × 8¼ in. (31.1 × 21.0 cm).

osity or bemusement; the other, with the most elaborate of the hats, continues her forward march. Their plumed headgear rhymes sardonically with the flag and flagpole and the twin spires of the church, gently undermining the respectful attitude toward church, state, and femininity that, two years later, Hassam embodied with paintings such as *Early Morning on the Avenue*.

While surely not intended by Strand as a commentary on the war in Europe, nor likely to have been viewed by anyone in that regard, *Fifth Avenue* captures the irreverent spirit of the Lyrical Left during the period in which preparedness advocates such as Hassam, Morgan, and Stimson were beginning to make their case. The Lyrical Left is a term that was later applied to a loose coalition of artists, intellectuals, professors, social workers, and political activists centered in Greenwich Village. In the decade or so before America entered the war, they believed—naively, it seems in retrospect—that radical artistic and sexual experimentation, together with radical politics,

Art for War's Sake

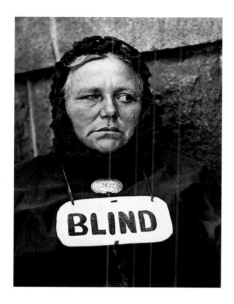

Figure 11. Paul Strand, *Blind*, 1915.
Gelatin silver print, 12⅞ × 9¾ in.
(32.7 ×24.8 cm).

could help demolish archaic social patterns and lead the way to a freer and more equitable society.[21]

Another of Strand's photographs from this time, and now one of the iconic images of American art history, *Blind*, provides a head-and-shoulders study of a sightless mendicant who stands with her back against a wall (Fig. 11). The medallion license on her neck authorizes her to beg—but it also resembles a slave shackle or dog collar. A large, hand-painted sign hung across her chest labels her "BLIND." Her sightless eyes angled obliquely from the gaze of the camera, the woman, her face weathered but handsome, her silver hair covered by a shawl, seems to be some sort of urban oracle or sibyl: blind, yet a seer.

As a teenager, Strand had attended New York's progressive Ethical Culture School, where one of his teachers was the documentary photographer Lewis Hine. Hine inspired his students to believe that photography could

Art for War's Sake

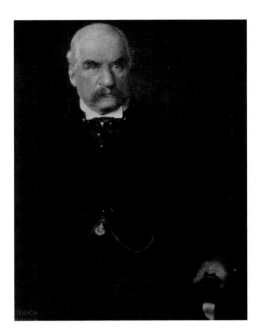

Figure 12. Edward Steichen,
J. Pierpont Morgan, Esq., 1903.
Photogravure (1906), 8¹/₈ × 6¹/₈
in. (20.6 × 15.5 cm). Philadelphia
Museum of Art.

and should be used as an instrument of social reform, and even when Strand, in the wake of the Armory Show and under the influence of his new mentor, Alfred Stieglitz, embraced modernist aesthetics, he remained committed to the social-reform principles he had imbibed from Hine. With *Blind*, the young photographer combined the divergent lessons he had learned from both his masters.

That is, the photograph is modernist in form, filled with angular symmetries and asymmetries that engage the eye in abstract relationships, but its formal complexity cannot dispel—if anything, it enhances—its social concerns. The picture indicts a capitalist economy that regards the sub-proletarian poor as unsightly marginal figures, who are best ignored or overlooked. In that sense, the word "blind" emblazoned on the woman's chest constitutes not her scarlet letter but ours; it levels a charge of moral blindness *at the*

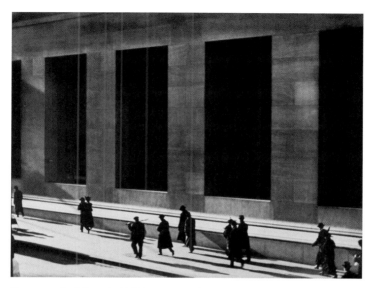

Figure 13. Paul Strand, *Wall Street*, 1915. Platinum print, 9¾ × 12¹¹/₁₆ in. (24.8 × 32.2 cm).

viewer who looks at poverty without sympathy or, more importantly, without a sense of outrage. The beggar does not reproach the better-off, who remain on our side of the camera lens, but the photograph most certainly does.

Blind holds its own against another iconic photographic portrait of the early twentieth century, Edward Steichen's 1903 depiction of J. Pierpont Morgan, Sr., who sat impatiently for the photographer and tore the resulting print to shreds when it was delivered to him (Fig. 12). And with good reason, too, for in the photograph the analogy between capitalism and piracy could hardly be more explicit: the scowling plutocrat, bathed in darkness, appears to be clutching a deadly knife in his hand, although, on closer inspection, the blade turns out to be the glossy arm of his chair flashing in the light.[22]

Though rarely recognized as such, Strand's 1915 photograph *Wall Street* (Fig. 13), the most famous picture he ever took, attacks the Morgan banking

empire. It also, indirectly, attacks the efforts of interventionists like Hassam, Stimson, and Morgan to pull the United States into the war. Published by Alfred Stieglitz in *Camera Work* in 1916 and exhibited by him at Gallery 291 in the same year, *Wall Street* portrays Gotham in a manner that seems strikingly unpatriotic compared with Childe Hassam's views of the city. The photo historian Glyn Davis aptly describes the picture: "Workers scuttle across the bottom of the frame, low sunlight stretching their shadows into dramatic diagonal smears; above the human figures towers an imposing bank, an edifice to the status and power of capitalism. . . . Wall Street, a global symbol of monetary might, dwarfs the nameless and faceless individuals exiled to the lower limits of the image."[23]

Strand's white-collar workers, isolated from one another by heavy shadows, march into the jaws of the impersonal corporate machine, represented by the vast coffin-like casements looming over their heads. In terms such as these Strand and his fellow cultural radicals in the Lyrical Left would have understood the image, which eloquently distilled their rancor toward capitalist America.

+ + + +

What a contrast to *Early Morning on the Avenue.* In both images, pedestrians pass beneath an immense edifice in the bright light of early morning, but in the painting it is a Fifth Avenue church and in the photo, a Wall Street bank. The painting exudes old-fashioned gentility, the photograph modernist alienation. The flags of the allied nations wafting above Hassam's Fifth Avenue shoppers symbolically safeguard them. Strand's Wall Street workers lack any such protection. Passive, unresisting, they herd to work like Eloi proceeding docilely to their slaughter by the Morlocks in H. G. Wells's late-Victorian science fiction allegory *The Time Machine* (1895) or, in a more historically apt analogy, like infantry heading to the front.

Years later, Strand recalled the impression the bank building had made on him. "I had a friend who worked in that building, with whom I went to school: for me it seemed too bad, I thought he could have done something much more useful. Well, I also was fascinated by all these little people walking by these great big sinister, almost threatening shapes . . . these black, repetitive, rectangular shapes—sort of blind shapes, because you can't see in, with people going by. I tried to pull that together."[24]

On another occasion, Strand recalled that "at that time I knew nothing about cartels etc. I was trying to photograph the 'rushing to work' and no doubt the black shapes of the windows have perhaps the quality of a great maw into which the people rush." As the photo historian Maria Morris Hambourg concludes, "Whether the shapes represent the consolidated power of Wall Street, the mad dash after money, the weekday routine, the inhuman quality of metropolitan life, the inexorable march of time, or some combination of these ideas, their oppressive regularity and crushing size, in contrast to the small individual human silhouettes below, constitute an abstract expression of [Strand's] emotional response."[25]

The Wall Street building beneath which they trudge is not any old building. It is the headquarters of the Morgan bank. The House of Morgan was instrumental in bringing the United States into the war. It floated loans worth billions of dollars to the British and French governments. During the two and a half years the United States remained neutral, the bank served as the purchasing agent for the British in North America, buying food and supplies to be shipped to England. In violation of neutrality laws, it also procured munitions.[26]

The *Lusitania* was carrying a contraband cargo of Morgan-purchased munitions, although this information was not made public until after the armistice. Even at the time of the catastrophe, many Germans and German American sympathizers, doubting that a single torpedo could have caused

an ocean liner to plummet into the sea so quickly, before lifeboats could be deployed, speculated that the underwater missile had inadvertently detonated a stockpile of illegal explosives in the ship's hold.[27]

Whether or not Strand and his fellow Greenwich Village radicals believed the rumors about the *Lusitania* carrying Morgan-funded munitions, they knew without question that the House of Morgan solidly favored US military intervention in the war on behalf of Great Britain. The full revelation of Morgan's involvement in the war materially changes the way we read Strand's representation of its headquarters. More than a generalized attack on Wall Street capitalism, it specifically manifests the Lyrical Left's animus against the war and its rich and powerful advocates.

Once war was declared, political criticism of Morgan or Wall Street could land a dissident in jail. A district court judge in New Hampshire sentenced a man named Taubert to three years in prison for obstructing bond sales by claiming in print that "this was a Morgan war and not a war of the people." The judge explained that he was being lenient in his sentencing: "These are not times for fooling. The times are serious. . . . Out West they are hanging men for saying such things as this man is accused of saying." The US attorney general, on another occasion, chastised a federal judge for acquitting a defendant who had publicly referred to the president of the United States as "a Wall Street tool."[28]

After the war, Morgan headquarters, erected in 1913, the year the elder Morgan died, became the symbol par excellence of corporate capitalism (equivalent, more than half a century later, to the World Trade Center). In September 1920 a horse-drawn wagon carrying five hundred pounds of iron sash weights pulled alongside the building at lunchtime. Moments later, the wagon exploded in a ferocious blast that killed thirty-eight people and injured three hundred others (Fig. 14). The young banker Joseph P. Kennedy, father of a future president of the United States, happened to be walking down Wall Street at the time. The force of the explosion hurled him to the

Art for War's Sake

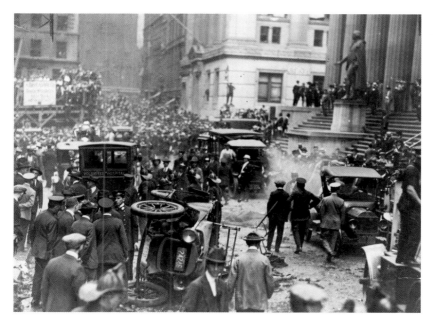

Figure 14. Crowd gathered following the explosion on Wall Street, car overturned in foreground, ambulance behind it, 16 September 1920 (note Washington statue in background). Library of Congress.

ground. Morgan's massive building survived the assault, though the huge recessed windows that loom over the pedestrians in Strand's photograph were punched from their casements. Investigators never identified the cause of the explosion, and an army of private detectives hired by the Morgan firm found no culprits to arrest, but it was widely believed that anarchists had plotted and executed the attack.[29]

Strand, though not an anarchist himself, abhorred the world presided over by the likes of Morgan, Stimson, and Hassam. On the eve of his induction into the army in the summer of 1917, he wrote to the radical antiwar journalist Randolph Bourne to thank him for his recent essay "Below the

Art for War's Sake

Battle," which Strand believed expressed his own disheartened feelings about the current state of America.

In the essay, Bourne describes an unnamed friend of his, who, "because his parents happened to mate during a certain ten years of the world's history," was being shipped overseas "to kill Germans or be killed by them." Bourne's young friend loathed "reputable people," those conventionally minded, well-off Americans who exhibited "neurotic fury about self-defense." Like the thousands of young pacifists, including Strand, that he typified, Bourne's friend had no use for the patriotic importuning of preparedness advocates. "All the shafts of panic, patriotism and national honor have been discharged at him," wrote Bourne, "without avail." The essay concludes, "If the country submissively pours month after month its wealth of life and resources into the work of annihilation . . . bitterness will spread out like a stain over the younger American generation. If the enterprise goes on endlessly, the work, so blithely undertaken for the defense of democracy, will have crushed out the only genuinely precious thing in a nation, the hope and ardent idealism of its youth."[30]

Surely few if any viewers would have compared *Early Morning on the Avenue* to Strand's *Wall Street,* if only because the audiences for the two images were so unalike. Hassam and his patrons and fellow artists lived in the same city as Strand and his friends and patrons but in a different world. They exhibited in very different venues and thought in very different ways about art and society and, in particular, the war in Europe. As indicated above, Hassam, Stimson, and Morgan strongly favored intervention; Strand, Bourne, and Stieglitz distinctly opposed it. Another reason that viewers of Hassam's painting were unlikely to have seen Strand's photograph is simply that, in those days, paintings and photographs would rarely be drawn into any kind of comparison; they, too, occupied distinct worlds (still the case today, though less so).

But that should not prevent us from taking the trouble to think of them

Art for War's Sake

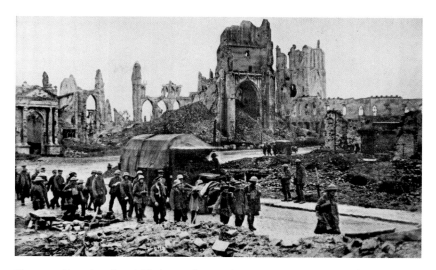

Figure 15. Ypres in ruins. *Collier's New Photographic History of the World's War* (1918).

comparatively. Hassam and Strand may have been politically and artisti-cally antithetical, but they were both highly proficient artists who used their well-honed skills of visual communication to envision, each from his own politically committed perspective, America's great metropolis as war beckoned.

To return, then, to Strand's foot soldiers of capitalism marching past the cathedral of commerce built by Morgan, we might juxtapose it with another haunting image of the period, this by a British Army photographer who recorded the damage done to the Belgian city of Ypres, the site of four terri-ble, long-lasting battles (Fig. 15). Appearing in *Collier's New Photographic His-tory of the World's War*, the photo shows captured German soldiers and their guards trudging along an abandoned avenue beneath the ruins of the town's once glorious High Gothic architecture. They provide a bleak counterpart to Hassam's pedestrians strolling down Fifth Avenue past a Gothic Revival church. Despite the obvious differences, Hassam's painting and the *Collier's*

Art for War's Sake

photograph are alike in that both invited Americans to think reverently or sentimentally about homeland, their own or that of the Belgians, whereas Strand's photo asks for a critical perspective on it.

+ + + +

Collier's New Photographic History of the World's War attracted a wide readership, attested to by the fact that it went through multiple editions. But, for the most part, photos from the front were not an effective way of swaying public opinion, if only because they were censored to ensure that Americans did not see genuinely frightening or grotesque images, which, in turn, might have caused them to withdraw their support for the war. Instead, an avalanche of official recruitment and bond-raising posters, together with a sudden glut of Hollywood melodramas, performed most of the visual labor of sustaining America's military enterprise. Between the declaration of hostilities in April 1917, and the end nineteen months later, government agencies, civic organizations, and manufacturers' associations distributed as many as two thousand different war posters in massive quantities throughout the land, their evocative colors, eye-catching designs, and unambiguous messages urging the public to stay the course.

These images range from the humorous to the harrowing, from sappy-sentimental to leering-lecherous, from blatantly obvious to cool and quizzical. Many are loud and brash, others quiet and insinuating. One can easily detect in these pictorial pitches the birthroots of modern commercial advertising. Indeed, many of the most successful advertising and public relations wizards of Madison Avenue during the twenties, thirties, and beyond learned their craft while working for the Creel Committee or apprenticing in the poster campaigns.[31] Some of these campaigns focused on recruitment and enlistment, others on wartime conservation of food and natural resources, and others on good citizenship in general. Perhaps the most concerted effort

of all was devoted to the four Liberty Loan campaigns that took place during the war and to a fifth that followed shortly after, the Victory Liberty Loan.

Liberty Loans were interest-bearing certificates sold by the US government to fund the war effort. The first campaign, occurring eighteen days after the declaration of war, was not considered successful. When the second campaign, launched in October, also failed to reach the hoped-for sales figures, the secretary of the treasury, William McAdoo, determined that the next Liberty Loan campaign would be heavily promoted. To that end, his office enlisted famous artists and illustrators to design posters and famous actors and actresses to travel through the country to make personal appeals to the public to purchase bonds.

During this campaign, which began in April 1918, the world's three most popular movie stars—Mary Pickford, Douglas Fairbanks, and Charlie Chaplin—addressed enthusiastic crowds of thousands everywhere they went. Pickford alone is said to have raised $5 million in a single day. Efforts such as these were supported by vast amounts of promotional materials distributed to crowds and plastered on walls: nine million posters, five million window stickers, and ten million buttons were distributed during this fund-raising drive.[32] Never before had a government launched such a massive campaign to mold the minds of its citizens through the appurtenances of visual art—in this case, not only through mass-produced posters, stickers, and buttons, but also publicity stories in newspapers and magazines and newsreel footage of Liberty Loan rallies, and, above all, through the patriotic, pro-war endorsement of celebrities such as Pickford, Fairbanks, and Chaplin, who were themselves, in the era of silent cinema, carefully manufactured visual artifacts. Recall Figure 7, showing Fairbanks, with the implied blessing of George Washington, addressing a crowd on Wall Street for the third loan campaign.

A wide array of colorful posters promoted the fourth Liberty Loan cam-

Art for War's Sake

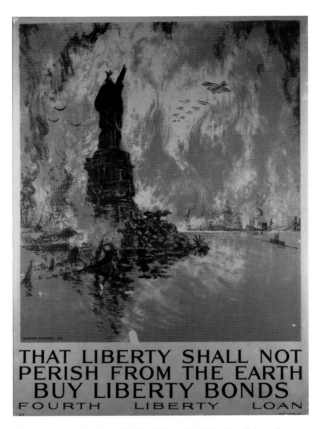

THAT LIBERTY SHALL NOT
PERISH FROM THE EARTH
BUY LIBERTY BONDS
FOURTH LIBERTY LOAN

Figure 16. Joseph Pennell, *That Liberty Shall Not Perish from the Earth—Buy Liberty Bonds—Fourth Liberty Loan*, 1918. Library of Congress.

paign, which began in late September 1918, but none was as dramatic and unsettling as the one designed by Joseph Pennell, a Whistler protégé in his youth who had since become America's most distinguished graphic artist (Fig. 16). In the apocalyptic scene Pennell envisions, the Statue of Liberty has been decapitated. Her famous head lies half-submerged in New York harbor,

Art for War's Sake

while enemy bombs turn Manhattan into a cauldron of smoke and flame. Pennell's poster, *That Liberty Shall Not Perish*, is one of the most unforgettable of the war because it so skillfully manipulates emotion-laden symbols of America, subjecting them to spectacular violence. A viewer can practically hear the violent buzz of the biplanes, the cascading thunder of the bombardment, the furnace-roar of the flames, and the shrieks of unseen citizens racing panicked through the streets.

The nightmare envisioned provides a dystopian counterpart to Hassam's light-drenched, flag-fluttering American metropolis. This is Hassam's sunny morning on the avenue wrenched upside down, a horror show having less to do with impressionism and its early twentieth-century variants than with the apocalyptic fantasies of Romantic-era British artists such as John Martin and J. W. M. Turner and their American contemporary Thomas Cole. Pennell most likely had Cole's much-reproduced 1836 history painting *Course of Empire: Destruction* in mind when he conceived his own version of Gotham's devastation. In Cole's allegorical depiction of an ancient Roman metropolis overrun by torch-wielding barbarians, a decapitated gladiator statue occupies roughly the same compositional location and is in the same condition as Pennell's Statue of Liberty.

Pennell described his original conception for the poster as "New York City bombed, shot down, burning, blown up by an enemy," while the caption was to read, "Buy Liberty Bonds or You Will See This." Government officials toned down the blunt language, but the rhetoric of the image itself was no less inflammatory than the incendiary bombs raining from the sky. Two million copies of this poster circulated throughout the land, filling Americans with anger and dread at the thought of an air strike on New York and increasing their determination to take the war to the enemy over there before the enemy brought it over here.[33]

+ + + +

Art for War's Sake

In April 1918, almost a year to the day that Congress declared war on Germany, Childe Hassam was arrested as a German spy. While sketching a camouflaged American transport vessel anchored in the Hudson River, he was stopped by a suspicious policeman who delivered him into the hands of federal authorities. Learning who he was, they promptly released the distinguished artist. He congratulated the policeman for his vigilance, saying that if everyone were as alert, "there would not be so many dangerous enemy aliens travelling about the country."[34]

Later that year, probably in early autumn, Hassam painted the most uncharacteristic work in the flag series. *The Flag, Fifth Avenue* looks across the southeast corner of Central Park, as represented by a flurry of blue brushstrokes in the middle ground, to an alignment of light-catching limestone structures on Fifth Avenue (Fig. 17). The painter impedes the view, however, by placing the back of a high-rise building smack in the middle of the composition and running a ridge of cluttered rooftops across the painting's base.

It is almost as if he has set out to violate his long-standing aesthetic principles and predilections by indiscreetly portraying not the dignified front of a building but its rear end and not looking up admiringly at an urban structure but looking down on it, showing the messy disarray that would be invisible from the street. For Hassam, this must have been equivalent to picturing a gentleman in his underwear. Perhaps he wished to demonstrate that he too could be an Ashcan School artist, if he so desired. The vignette at the lower left of a washerwoman or housewife hanging laundry to dry is straight out of John Sloan's series of paintings of his neighbors doing the same on the Lower East Side, as, for example, in *Sun and Wind on the Roof* (1915, Maier Museum of Art, Randolph College).

But it is not only the uncouth subject matter and behind-the-scenes vantage point that make *The Flag, Fifth Avenue* so unusual for Hassam. What is really strange about it is the flag itself, great in size but "flagging," so to speak, in energy. It appears heavy, worn, fatigued. Other adjectives come to

Art for War's Sake

Figure 17. Childe Hassam, *The Flag, Fifth Avenue*, 1918. Oil on canvas, 32³/₄ ×
27¹/₄ in. (83.19 × 69.22 cm). Private collection. Courtesy of Virginia Museum of
Fine Arts, Richmond, Virginia.

mind: deflated, dispirited, limp. We might wonder if the artist himself was
unintentionally confessing, by way of this symbol, to a sort of phallic defla-
tion of his professional potency, even as he attempted to vie with his younger
rivals, the urban realists, in conveying a side of city life he normally kept out
of sight.

Art for War's Sake

Whatever personal and professional meanings the lifeless flag in the painting held for Hassam, it points to a larger political meaning, especially when considered in contrast to the exuberant flags that danced in the breeze and rippled in the sun or braved the rain in almost all of the other works in the series. One senses here an admission of national exhaustion, a weariness of war and all the high-flying rhetoric that accompanied it. Old Glory appears not so glorious anymore. In this regard, the painting seems prescient of the mood that prevailed throughout much of the United States as the war drew to a close. For Hassam, it is an unusually quiet and introspective painting, one that looks inward, perhaps in a manner that anticipates the isolationist mood of postwar America, in which the public turned away from grandiose ideals (making the world safe for democracy) and schemes (the League of Nations, which it roundly rejected) and sought instead to tend to its own dirty laundry.

A curious architectural detail within the painting complicates our reading of it in terms of the war. At the base of the flagpole there is a strange, greenish-blue shape, not immediately recognizable. Research into the precise location of the buildings in the foreground reveals this to be Hassam's rendering of the backside of the imperial German eagle that had formerly adorned the *Deutscher Verein*, New York's elegant German Club. Erected in 1890 at 112 W. 59th Street (Central Park South), the five-story Renaissance-style building was presided over by a bronze eagle. The structure was abandoned during the war and the eagle removed from its perch, but Hassam, who would have been familiar with it from the vantage point of his studio on 58th Street, has restored the symbol of imperial Germany to the rooftop and juxtaposed it with the symbol of America.[35]

All the more, then, does the painting suggest the Pyrrhic nature of America's triumph over its enemy. Yes, Hassam's land of the free, the homeland made safe for wives, mothers, and daughters, the America of the pilgrim fathers, had stood its ground against the barbaric hordes in Imperial

German uniform. But what would happen next, when the barbarians who attacked the citadels of culture were dressed instead in workingman's uniforms or the garb of illiterate peasants from southern Europe and poor blacks from the American south—or, for that matter, in the informal attire favored by Bohemian artists from Greenwich Village? Could the flag withstand these assaults, too?

I do not mean to say that the painting answers, or even directly asks, such questions. Yet, indirectly, by its uncharacteristic iconography, it does raise them. Hassam gives us the back rather than the front of a building, a cluttered, disorganized rooftop, window shades of various colors pulled down to varying heights (later to become a signature device in the melancholy urban art of Edward Hopper), a washerwoman hanging out the laundry, and, above all, a huge, deflated, drooping flag. Compared to the typical exuberance of Hassam's flag paintings, this late entry in the series emblematically portrays a nation in transition. It conveys what was already, by 1918, becoming a faltering swagger and newfound unease about the shape of America's future.

Fixing Faces

In August 1928, *Vanity Fair* magazine sent the highest-paid photographer in the world, Edward Steichen, to Hollywood to photograph the most beautiful woman in the world, Greta Garbo. Notoriously private, restricting her sets to all but essential personnel, the Swedish Sphinx, also known as The Face, was prepared to grant Steichen five minutes of her time during an interval in the shooting of a potboiler entitled *A Woman of Affairs*.

In preparation for his brief audience with her, Steichen later recalled, he improvised a small photographic studio in an adjoining room and draped a dark cloth over a kitchen chair. While waiting for his sitter to appear, he peeked voyeuristically through a crack in the wall to watch her shoot a scene. It was not going well, and the director called for numerous retakes of what would prove to be one of the longest and most intense passages in the film. Garbo's character, clad in widow's weeds, endures the ordeal of an inquest into the death of her husband, who had flung himself from a window, allegedly because of her infidelity. Garbo seethes with conflicting emotions—those demanded by her role, but also, perhaps, by her frustration and anger with her director. It was at this point that he called for a break and that Garbo, still in costume, entered the makeshift studio and sat for Steichen.

She straddled the chair, resting her arms on its back, and Steichen quickly made five or six exposures. But something was not right. He was bothered by her hair, which looked like a movie hairdo, and dared to men-

tion it. "At that," he writes in his autobiography, "she put her hands up to her forehead and pushed every strand of hair back away from her face. . . . The full beauty of her magnificent face was revealed" (Fig. 18). Liberated from her feminine hairdo and attired entirely in black, with no jewelry or other softening accoutrements, Garbo seems severe and masculine, almost militantly so—except, perhaps, for the largeness and luminosity of her eyes, which look directly at, if not through, the viewer. According to Steichen biographer Penelope Niven, "The haunting picture that emerged from that revealing instant is one of Steichen's best-known images, as well as the single picture by which many movie fans came to remember Greta Garbo."[1]

A decade after the end of the Great War, no face was more iconic, more fetishized and invested with collective fantasy, than that of Greta Garbo. As reproduced in fashion and news magazines and on posters, billboards, and movie screens, Garbo's face embodied a sort of perfection beyond perfection. The essence of Garbo's image and the reason it had such power over viewers was that it amalgamated a flawless, godlike exterior with a deeply flawed, all-too-human, pain-ridden psychological interior. She was the transcendent movie star of her age because her face seemed to reveal dimensions of inner torment that were palpably real, not faked for the camera. The best moment in any Garbo film was the one in which her fixed, mask-like perfection suddenly, but only fleetingly, crumbled into helplessness and pain. Her emotional vulnerability onscreen was frightening and beguiling.

"Was there ever a more melancholy star than Greta Garbo?" the German scholar Klaus-Jürgen Sembach has recently asked. "What a feeling of loss she conveys, even in a smile. The older this woman grows, the more intense the aura of suffering around her. Deep-rooted pain shimmers through the glamor." Examining Garbo's appeal to her contemporaries, Sembach observes, "Melancholy is an essential ingredient. It is this melancholy which tells us that we are confronted with a case without redemption. How else could we—living out our everyday lives—feel that there was something

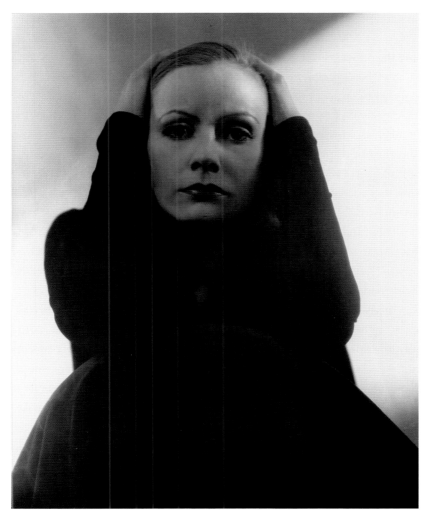

Figure 18. Edward Steichen, *Greta Garbo*, 1928. Gelatin silver print, 16½ × 13⅜ in. (42.2 × 33.9 cm). George Eastman House.

more, if not through that mute reproach? Cheery secrets are unimaginable. The forest is darker than dark, the ruins are more maze-like than a maze, and the princess is terribly fragile, enchanted and wide-eyed."[2]

Steichen's photo of Garbo captures this feeling of a forest darker than dark. It is contrapuntal in its rhythms of gray, black, and white, its asymmetrical angles, and massing of forms. The black, cloth-covered back of the chair creates an earth-like mound or bulwark from which her forearms, also sheathed in black, rise up like frames around her extraordinarily beautiful face, set at a slight angle against the broad swath of incoming light. Her lips, darkened with lipstick, compress themselves above her chin; her eyes are moist and searching, her eyebrows plucked, lined, and arched, her forehead high and broad, sculpted with light and shadow, her hair, in its pulled-back state, like that of a young man, and her hands, which were praised by adoring fans almost as much as her face, fold over her scalp in a protective, helmet-like manner.

This is not a typical glamour portrait. A glamour portrait is meant to elicit envy on the part of the viewer and to represent a highly desirable but virtually unattainable happiness and success.[3] Here, as I see it, the sitter appears almost despondent. Not everyone would have viewed it that way, of course, but when you begin to add up the signifiers, as we shall do, what emerges is a picture not of glamour but depression. Like Edvard Munch's *Scream*, it uses a hands-to-head gesture to convey despair. Garbo seems sad beyond words, clutching at herself, holding herself together, her face a tragic mask that, the photograph suggests, mirrors the tormented inner reality of its wearer.

Steichen's portrait of Garbo provides a powerful emblem of America in the aftermath of the Great War. It is a mourning picture. Perhaps it was not intended as such by the sitter or the photographer or interpreted as such by the readers of *Vanity Fair*. Nonetheless, let us regard it as a sort of war memorial, a testament to loneliness and alienation, beauty and death, and the inevitable loss of ideals. It may seem far-fetched to think of it in that way, but in

Fixing Faces

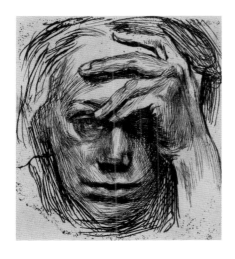

Figure 19. Käthe Kollwitz, *Self-Portrait with Hand to Forehead*, 1910. Etching, $11^3/_{16} \times 7^9/_{16}$ in. (28.4 × 19.2 cm). Harvard University Art Museums.

the broader context of the postwar era, it is not inconceivable. On the other side of the Atlantic, the German printmaker and sculptor Käthe Kollwitz, later to be ostracized by the Nazis as a degenerate artist, sculpted *The Grieving Parents* (1925–32, German war cemetery, Vladslo, Belgium), a private monument showing two figures, herself and her husband, kneeling at the grave of their son, who was killed in Flanders at the start of the war. The figures are separate from one another, each swaddled in grief; the female figure, a self-portrait of the artist, is cloaked in monk-like robes, clutching at her shoulders. In an earlier self-portrait, a charcoal drawing from 1910, Kollwitz, who struggled with depression, shows herself leaning forward and gazing straight ahead, her hand draped protectively over her forehead (Fig. 19).

That Steichen's portrait of Garbo would have certain similarities is not surprising, inasmuch as Steichen was a sophisticated, internationally renowned painter and art-photographer before he ventured into fashion photography, and he was almost evangelical in his devotion to European modernism. Garbo, meanwhile, had starred in G. W. Pabst's dark masterpiece of

Weimar realism, *The Joyless Street* (1925), before moving to Hollywood, and she too was determined as an artist to convey depths of meaning beyond surface appearance. Pabst's film, the story of a country girl who struggles morally and physically to survive when she moves to the city, combines German expressionism, a cinematic style reliant on an extreme externalization of inner mood, with New Objectivity (*Neue Sachlichkeit*), a more detached and distant, but not necessarily less socially critical, way of observing human activity and tragedy. In the role of the emotionally tormented country girl, Garbo fused these antithetical modes in a manner that electrified viewers. Steichen was well aware of these competing currents in modern visual representation, and his photo of Garbo beautifully draws on both of them.

During the war he commanded an aerial reconnaissance unit in the Air Division of the American Expeditionary Force. The purpose of the unit was to make high-altitude photographic renderings of enemy installations on the ground. Thus he saw the war mostly from the air, and yet he was appalled by the levels of destruction he encountered firsthand, both from on high and below. As Niven writes, "In France at the war's end, Steichen was a hero, honored for his innovations, bravery, and service. No honors, however, could redeem or obliterate the personal depression that descended after the armistice of November 11, 1918." While others in camp were drunkenly celebrating the end to "wholesale murdering," Capt. Steichen retreated into his barracks and flung himself on his bed. As he recalled:

> The whole monstrous horror of the war seemed to fall down and smother me. I smelled the rotting carcasses of dead horses, saw the three white faces of the first American dead that I had seen. I could hear the rat-a-tat-tat of machine-gun fire as one lay flat on one's belly trying to dig into the earth to escape it, and the ping-ping-ping of the bullets coming through the leaves overhead. I saw the dried blood around the bullet hole in a young soldier's head. And he was only one of hundreds of thousands. What was life for if it had to end like this? What was the use of living?[4]

Recoiling from the horrors he had witnessed on and above the battle-field—and to which he himself had contributed ("I could not deny to myself having played a role in the slaughter"), Steichen eventually made his way back to New York and, within a few years, launched himself as America's leading fashion photographer. It was during this period that he photographed Garbo clad in black, her clothing androgynous, her mode of seating masculine, and her hair cropped by her hands and pressed close to her scalp, like that of a young recruit. Ten years after suffering through the personal anguish of that armistice night, he photographed The Face as if she were a widow in mourning (consonant with her film role), but even more so in a manner suggestive of a dead person rising from the grave or a haunted soldier peering over a trench embankment or a tormented witness who, like he himself a decade earlier, had stared into the empty eye-sockets of death more than once, only to ask himself what was the use of living.

Let us use Steichen's photographic rendering of The Face as a jumping-off point to contemplate the fate of men's faces, and women's faces, too, in the armed struggle of the preceding decade. The brutality of that worldwide upheaval affected the disposition of faces—their ideological significance, aesthetic value, and material reality—as never before in the history of armed conflict. The Great War, after all, was the first major conflict to rely on trench warfare. The battle lines ran for five hundred miles, from the English Channel to the foothills of the French Alps. While these trenches protected men's bodies, they often left their heads exposed. A sniper's bullet could shear off the jaw or tear away the nose of a man who had the misfortune to raise his head at the wrong moment (Fig. 20).

Advances in battlefield medicine and transport services proved remarkable in saving the lives of those who in previous wars would have succumbed immediately or within days. A British nurse, writing a letter home about her duties at the front, reported: "I have seen [survivors] without faces, without eyes, without limbs, men almost disemboweled, men with hideous trun-

Figure 20. American soldiers in trenches, France (near Verdun), 1918. Library of Congress.

cated stumps of bodies." An ambulance driver recalled the time she looked down on her stretcher to see a "gibbering, unbelievable, unbandaged thing, a wagging lump of raw flesh on a neck that was a face a short time ago." As never before, soldiers could have their faces pulverized beyond recognition and yet not die from their wounds.[5]

At first, those who had been defaced were crudely patched up in military hospitals and hurried back to the trenches as soon as they were able to stand. Not surprisingly, troop morale suffered from the presence of the grievously disfigured. If facially injured soldiers were to return to the front without frightening and appalling their comrades, their faces needed to be

Fixing Faces

put back together. Hence, modern plastic surgery was born out of wartime necessity.

Military surgeons, working in extreme conditions, developed ingenious methods for reconstructing obliterated faces. When surgical intervention came up short and faces proved to be too damaged to repair, prostheses were devised: artificial chins, cheeks, and noses that could be affixed to a shattered face by means of a pair of eyeglasses and a false moustache.

It was one thing to mend faces so that soldiers could return to battle. But returning home presented new challenges. The public recoiled from the sight of men with mangled faces, since no one wanted to be reminded of the terrible war and the human sacrifices it had entailed. Despite shortcomings, the improvements wrought through plastic surgery were impressive. Indeed, they demonstrated that the face was malleable and that appearances could be changed for the better. Women in particular picked up the charge; if faces that were half blown-away could be made more palatable, how much more could be done with theirs?

The presence of defaced veterans affected the realm of modern art as well. Artists reacted to the war's lingering brutality in aesthetically opposed directions. Some sought to expunge all ugliness and impurity from art, while others, primarily from the defeated nations, reveled in violent, misshapen forms. Either way, the conflict left its mark.

Commentators have often noted the hedonism and beauty obsession of a decade variously known as the Roaring Twenties, Jazz Age, and Flapper Era, where female subjects in particular were urged by manufacturers, retailers, advertisers, and the entertainment media to enhance their aesthetic appearance, and thus their lives, by means of material acquisitions, beauty regimens, and fanatical devotion to fashion trends. No better sign exists of the new beauty fetish of the period than the Miss America beauty pageant, which was created in 1921 in Atlantic City, New Jersey, by local civic

Figure 21. The first "Miss America," Margaret Gorman, 1921.
Library of Congress.

promoters and contested by cherub-faced young women garbed in reveal-
ing bathing attire that many onlookers considered indecent (Fig. 21). Men,
too, embraced the new regime for themselves, as evidenced by the sudden
growth in bodybuilding programs and male dieting plans.[6]

We can only speculate that the all-too-visible "ugliness" of defaced or re-
faced veterans gave rise to, or at least intensified, the beauty obsession of the
postwar decade. Listing synonyms for the word "ugly"—grotesque, hideous,

Fixing Faces

homely, monstrous, unappealing, and vile—helps us to see that the war, an international orgy of ugliness that blighted cities, landscapes, and bodies, as well as minds and ideals, led to a powerful and sustained aversion to unattractiveness in any form, and hence to a counter-orgy, so to speak, of pulchritude.[7]

I am arguing here that a phobic reaction on the part of the American public to unsightly, war-induced injuries, scars, and deformities resulted in a compulsive search for beauty. Or, to put this formulaically: mutilation drove beautification. The ability of women, and men, too, to be satisfied with the "plain" appearance of their own faces suffered because of the war; their relative peace of mind in this regard was seriously eroded and can even be regarded as collateral damage of the war, though not recognized as such. And yet, because a variety of American industries, including film, advertising, publishing, medicine, psychiatry, and cosmetics, profited enormously from this newfound and widespread sense of insecurity about physical appearance, it amounted to a war dividend as well.

In Garbo's face we detect both aspects: damage and dividend. So ubiquitously seen in magazines, posters, and movies of the day, so much talked about in the press, and so much idealized and imitated through various modes of consumption, Garbo's face was a perfect emblem for the era, attesting at once to a craving for flawless, ageless, unblemished beauty and to the unremitting anxiety that such craving fails to keep at bay.

Near the close of the Second World War and writing from Moscow, where he had taken refuge from the Nazis, the Hungarian filmmaker, librettist, and film theorist Béla Belázs asked himself, why should Garbo's "strange sort of beauty affect millions more deeply than some bright and sparkling pin-up girl"? In keeping with his Marxist convictions, he decided that the secret lay in her "sad and suffering beauty" and her "gestures expressing horror at the touch of an unclean world." Even "the usually insensitive person," Belázs contends, can understand and appreciate her sadness "as an expression of opposition to the world of to-day." He concludes, "Millions see in her face

a protest against this world, millions who may perhaps not even be conscious as yet of their own suffering."[8] I would agree with Belázs here, except to qualify his insight by historicizing it, claiming that Garbo's sad, beautiful, mask-like face eloquently bespoke the intolerable losses of a war that, a decade or more after its conclusion, the public could sanitize, memorialize, and repress but never entirely forget.

That, in short, is what I hope to explore in this chapter: how the human ugliness unleashed by industrialized warfare led to a ratcheted-up pursuit of beauty and, at the same time, an obsessive fascination with bodily deformities. Along the way we will see how masks, both literal and symbolic, took their place as central tropes of modern and modernist existence.

+ + + +

During the six-month-long Battle of the Somme in 1916, an ear, nose, and throat surgeon from New Zealand, Harold Delf Gillies, treated over two thousand cases of facial injury at his clinic in Britain. His surgical exploits made him legendary among fellow wartime physicians, and he was knighted for his service to the crown. Later in life, when he was in his sixties, Gillies pioneered sex reassignment surgery and in 1946 performed the first successful male-to-female operation. As in his previous explorations in reconstructive plastic surgery, the doctor was motivated by a profound sympathy for the psychological suffering of his patients. To Gillies, the grief caused by the loss of a face was impossible to ignore. In his memoirs, he writes of a patient who had been quite handsome before he was wounded: "We had done a reasonable job, considering the amount of tissue lost. Mirrors were banned from the ward but that boy had a small shaving glass in his locker. At the sight of himself he collapsed. All hope of allowing his girl to visit him died with that forbidden glimpse. From then on he insisted on being screened from the rest of the ward patients. When at long last he went home it was to lead the life of a recluse." The surgeon adds dryly, "Only the blind kept their spirits up."[9]

Sometimes, as he notes elsewhere, plastic surgery simply managed to make a horrible face ridiculous. In his memoir of Paris in the twenties, Ernest Hemingway recalled *les gueules cassées* (the broken faces), men whose reconstructed flesh possessed "an almost iridescent shiny cast . . . rather like that of a well-packed ski run." French director Abel Gance's epic anti-war melodrama *J'Accuse*, filmed in the late stages of the war, released in 1919, and remade in 1937 with some of the original footage incorporated, climaxes with a terrifying march of resurrected war dead, the parts played by actual *mutilés de guerre* and *gueules cassées*.[10]

In 1916 the *New York Times* reported: "It was the frightfulness of the men who had got quite well, who were distorted, made unforgettably terrible, whose faces were half gone," that most unnerved those who encountered them in the street. For that reason they generally kept to themselves, form-ing, in at least one postwar instance, a "ruined faces club." To use a term popularized in Paris in the mid-twenties, albeit not in reference to them, the men with broken faces were "surreal" (Fig. 22).[11]

After the armistice, teams of American surgeons who had observed Gil-lies's techniques at close range during the war invited him on a ten-week lecture tour of the United States. In those days plastic surgery was consid-ered a minor, even aberrant, medical practice, the province of charlatans and quacks, and they wanted to demonstrate to their skeptical medical col-leagues the marvels that modern plastic surgery had accomplished. Gil-lies illustrated his lectures with numerous before-and-after clinical pho-tographs of his patients, recording their facial injuries and the subsequent stages of reconstruction. He published many of these photos in his landmark medical textbook, *Plastic Surgery of the Face*.[12]

The pictures labeled "after" are often as grotesque as the ones captioned "before." The patients come across as human gargoyles. Take, for example, William M. Spreckley, whose nose was blown away at the Battle of Ypres (Fig. 23). After two years in hospital and multiple surgical interventions

Figure 22. A gathering of the Ruined Faces Club, France, ca. 1920. Collection Sirot–Angel.

(Fig. 24), he regained an almost normal appearance (Fig. 25). According to his granddaughter, however, his physical scars healed but not the psychological ones, and to the end of his days—he lived into his sixties—he considered his appearance hideous (Fig. 26).[13]

Figure 23. *(Opposite, top left)* William M. Spreckley without a nose, 22 February 1917. From the Archives of the Royal College of Surgeons of England.

Figure 24. *(Opposite, top right)* Spreckley during reconstruction of nose, 29 December 1917. From the Archives of the Royal College of Surgeons of England.

Figure 25. *(Opposite, bottom left)* Spreckley, further along, 23 August 1918. From the Archives of the Royal College of Surgeons of England.

Figure 26. *(Opposite, bottom right)* Spreckley in later life (undated). From Gillies and Millard, *Principles and Art of Plastic Surgery* (1957).

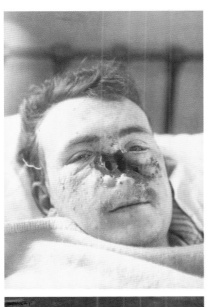
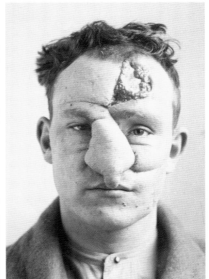
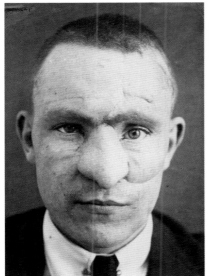
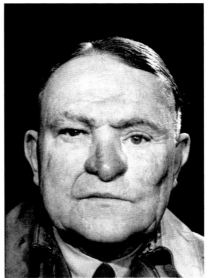

Gillies commissioned pastel portraits of his patients to be made by Henry Tonks, a Royal Academy artist who was also a trained physician. Tonks's renderings are beautiful objects in their own right, even though, or perhaps because, they render human suffering in vivid color, showing individuals who in many cases had to endure not only grievous wounds, multiple surgical interventions, and months or years of virtual imprisonment in hospital wards, but a lifetime ahead of causing strangers to shrink from them in fear, if not outright disgust.[14]

What makes Tonks's pastel portraits and the photographs in Gillies's book particularly unsettling—more so, perhaps, than in a medical textbook chronicling grievous wounds to the body—is that the patients often look perfectly normal in the parts of their faces that did not sustain damage. Take, for example, the portrait of a mutilated serviceman (Fig. 27). Cover the lower part of his face with your hand, and he seems normal, even handsome. Reverse the process, and he is a monster. The discrepancy between the normal and the monstrous within the same face can seem uncanny. Were the flesh thoroughly removed or the bones completely crushed, one would be less likely to recognize the humanity within these faces. But, instead, troublingly, the markers of the men's human agency remain intact. It is thus impossible to protect one's own feelings by viewing the mangled and distorted countenances coldly and objectively as lifeless, insensate, inhuman matter.

+ + + +

Plastic Surgery of the Face had limited circulation and was intended only for the eyes of clinical professionals. Such was not the case with another postwar volume filled with visual evidence of the war's capacity to inflict pain and suffering. This was *War against War!,* a photo album first published in Berlin in 1924 and multiply reprinted during the remainder of the decade. With its ironic juxtapositions and acerbic captions, the book circulated

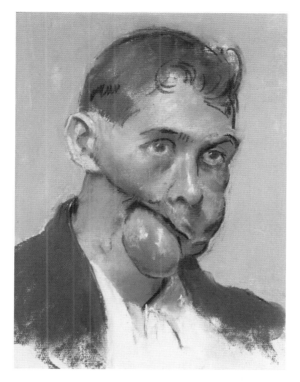

Figure 27. Portrait of a serviceman by Henry Tonks, 1916–1918. Pastel on paper, 10½ × 8⅛ in. (26.6 × 20.6 cm). Hunterian Museum at the Royal College of Surgeons of England.

worldwide under the auspices of the international trade union movement. More than a million copies are said to have found their way into workshops and homes around the globe.[15]

The volume is filled with page after page of sprawling corpses and cadaverous survivors. Human remains are strewn across barren fields watched over by feral dogs. Bodies swing from ropes, and severed heads adorn the tips of bayonet blades. Armies of amputees hobble on makeshift crutches.

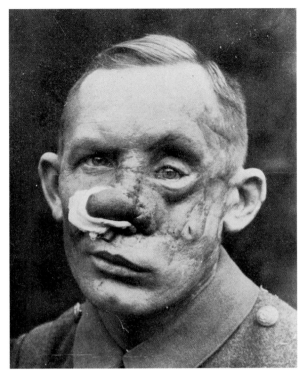

Figure 28. Wounded agricultural worker from Friedrich, *War against War!*

This circus of horrors is climaxed by a succession of disfigured faces, some with deadpan captions: "Nose blown away and restored with flesh from upper thigh"; "Mouth and teeth torn away"; "Lower jaw and teeth blown away" (see Fig. 28). Other captions are sarcastic: "A noble gift of heaven is the light of the eye" declares the text beside a photo of a man with empty eye sockets.[16]

These photos call to mind the much later work of the Anglo-Irish modernist Francis Bacon, as seen in a self-portrait from 1969 (Fig. 29). Bacon,

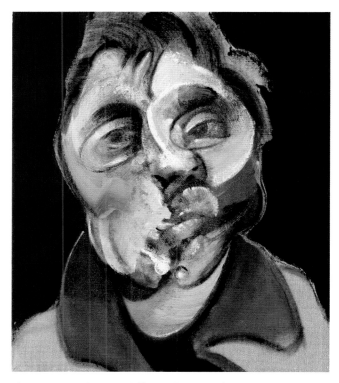

Figure 29. Francis Bacon, *Self-Portrait*, 1969. Oil on canvas, 14 × 12 in. (35.56 × 30.48 cm). The Estate of Francis Bacon.

who hoarded grisly photographs, may well have owned a copy of the book; in any case it is probable that he ran across it during the two months he spent in Berlin in 1927, deeply absorbed in the radical art, photography, and film that was pouring into and out of Weimar Germany at that time. To be sure, cubism and surrealism, both of which profoundly affected him as an artist, and his firsthand experience of the Blitz at the start of World War II, factor into the mortified-flesh aspects of his work much more than any single book would have done, and yet it is nonetheless likely that his febrile

imagination fed off images such as those contained in this bitter compendium of banned atrocity images.

The creator of *War against War!* was Ernst Friedrich, a young German anarchist who, during the course of the war, was initially confined in a mental institution and subsequently imprisoned because of his outspoken pacifism. After his release from prison, following the armistice, he began gathering photographic evidence of the atrocities committed on all sides. Before the publication of this book, the public was largely unaware of these atrocities. Government censorship had successfully blocked the use of photographs depicting dead or wounded soldiers unless they were *enemy* soldiers—and even then usually only photographed from a distance, to prevent their being seen as objects of concern or pity. For those who had not witnessed the ravages of war with their own eyes, Friedrich's photo collection was a first look at the devastation inflicted on villages, towns, countryside, and, most shockingly, human flesh.[17]

The book seems to have served a purpose similar to that of a now-lost French documentary film made shortly after the war, *Pour la Paix du Monde*, compiled from film strips in the archives of the French armed forces. According to Béla Belázs, the movie concerns the "men who lived like lepers in an isolated, secret community of their own, because the sight of them would have been unbearable to their fellow-men. The film begins by showing these faceless ones in close-up, their mutilations covered by masks. Then they take off their silken masks and with it they tear the mask off the face of the war."[18]

The moral power of this film resides for Belázs in this: "Those whom the war has robbed of their faces show the true face of war to those who know nothing of it. And this physiognomy of war is of an emotional power, a force of pathos no artistic feature film about the war had ever attained. For here war is presented by its victims, horror is presented by the horrified, torture by the tortured, deadly peril by those endangered—and it is they who see these things in their true colors."

Likewise, Friedrich wanted to repel—indeed, create physical revulsion in—ignorant idealists, those who believed in the moral justness of war, and cynical pragmatists, who profited from it economically, by confronting them with unmistakable evidence of its ugliness. The images in *War against War!* treat the men's face wounds in a fetishistic manner, eliciting from the viewer an almost voyeuristic compulsion to look and look away at the same time. Like pornography, these visceral images toy with the viewer's sense of boundary and taboo. As Susan Sontag noted in her final book, *Regarding the Pain of Others*, pornographic pacifism, like pornographic sexuality, ultimately has a depoliticizing effect, causing viewers to become mired in or mesmerized by the carnality of abject flesh.[19] By these lights, Friedrich's effort was doomed to fail, regardless of its laudable intentions.

War against War! emerged out of a specific culture, postwar Berlin, in which amputation and disfigurement were common sights. Men who bore their stigma were easily overlooked by ordinary Berliners rushing about their business or pleasure. At an earlier time, they would have been shocked by what they saw on the street, but by now they were inured to the presence of the war-deformed and defaced.

As such, then, the latter had become invisible men, but not to German expressionist or New Objectivity artists such as Otto Dix, George Grosz, and Ernst Ludwig Kirchner, themselves physically or psychically damaged war veterans. In a disturbing self-portrait, Kirchner depicts himself in uniform as a painter with an amputated hand, which was not literally the case. Burning with resentment at a fatherland that had fed its offspring into the meat-grinder, these artists often depicted crippled, infirm, or insane survivors of the war, but without sentimental sympathy. Instead, they pictured the deformed and mutilated victims of combat as human monsters, mirror images of the monstrous society that produced them (Fig. 30). Propped up on crutches, patched together with steel plates in their heads, leering with hunger and desire, these former men of war appear in postwar German art

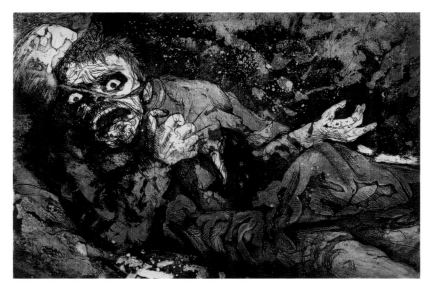

Figure 30. Otto Dix, *Wounded Soldier (Autumn 1916, Bapaume)*, 1924. Etching and aquatint, 7⁹/₁₆ × 11³/₁₆ in. (19.2 × 28.4 cm). Harvard University Art Museums.

as human refuse, boils and scabs festering on the body politic (Fig. 31). Aging and overweight prostitutes in their paintings serve a similar function. This is the Berlin that Greta Garbo inhabited in 1924 while shooting *The Joyless Street*. The title aptly conveys the sensibility characteristic of the New Objectivity: a hard, gimlet-eyed realism regarding the inequities and moral failings of postwar society. Garbo moved thereafter to Hollywood and starred in films of a remarkably less realistic or socially critical nature, but, personally, she never surrendered the bleakness of this worldview. The Steichen photograph seems to show it blazing in her eyes.

It is difficult to find in the art of Germany's former adversaries, Britain, France, Canada, Italy, Belgium, Russia, and the United States, an equivalent expression of outrage about the war and its human cost. During the postwar period, artists in those nations danced around the subject of the recent

Fixing Faces

Figure 31. George Grosz, *The Hero*, ca. 1932. Lithograph on paper, 12¹¹/₁₆ × 8¹³/₁₆ in. (32.2 × 22.4 cm). University of Michigan Museum of Art.

war or ignored it altogether. The governing aesthetic, known as "the return to order," called for art to be cool, even Apollonian. Many avant-garde artists abandoned the formal or emotional radicalism typical of the prewar years and embraced instead the tranquilities of neoclassicism, lauded the intricate beauty of machinery, explored hard-edged geometry, found refuge in regionalism, or delved into dreams, sexuality, and the baffling logic of the unconscious. They left the war as far behind as possible. To refer to it directly and explicitly was to commit an artistic faux pas. Let the losers harp on the destruction, the victors may have concluded—after all, hadn't they caused it?[20]

One conspicuous exception was the American painter Ivan Albright, who is little known today, except perhaps for his monstrously ugly portrait of Dorian Gray, which appears at the climax of a 1943 Hollywood murder melodrama based on Oscar Wilde's allegorical tale. Albright specialized in pictures of corrupted, putrescent, repulsive flesh and thus was the perfect choice of an artist to envision for screen viewers the magical painting that absorbs and reflects the inner ugliness of the tale's preternaturally ageless and morally reprehensible title character. As an impressionable twenty-year-old, Albright had served as a medical illustrator in an army hospital in France, where his job was to record in meticulous and unemotional detail the travails of the body in pain. He never managed to shake this experience, and it seems to have informed his outlook. He is merciless in his depiction of humanity. *Into the World There Came a Soul Called Ida* (1929–30) shows a corpulent and decrepit old lady, clad in lingerie, seated at her makeup table as she gazes into a handheld mirror, her sagging flesh, low-hanging breasts, and purplish mottled legs examples of what Albright referred to as the "corrugated mush" of the human body (Fig. 32). The painting's model, Ida Rogers, was then an attractive twenty-year-old.[21]

The portrait is a modern-day version of the traditional *vanitas* painting that draws attention to the inexorable passage of time and the inevitabil-

Figure 32. Ivan Albright, *Into the World There Came a Soul Called Ida*, 1929–30. Oil on canvas, 56¼ × 47 in. (142.9 × 119.2 cm). The Art Institute of Chicago.

ity of death. But also, in its own way, it is as much a testament to the ugliness of the recent war and the decadence it spawned as the ugly-prostitute paintings of Dix and Grosz. Working slowly and on his own in a small Illinois town, not a part of any art movement, Albright was less direct than they, but he too testified through paint to the savagery he had witnessed on or near the battlefield and the hopelessness that he and many others of his generation continued to endure long after the armistice was signed.

Fixing Faces

+ + + +

In the middle of the war, a handful of British, French, and American art-
ists became involved in sculpting life masks for men with irreparably muti-
lated faces; that is, faces so badly broken that they were beyond surgical
repair. The masks were meant to create the illusion that those who wore
them resembled themselves as they had looked before they lost their faces.
This marked a major change of attitude toward masks in general, which were
previously regarded as evidence of immorality and deception, the accoutre-
ment of bank robbers and licentious libertines. In the new climate brought
on by war, masks could be seen instead as humanitarian technologies, pros-
thetic devices that would allow a severely disfigured veteran to walk again
among the living.[22]

In an effort to offset the manifest deficiencies of plastic surgery, Gillies's
colleague Capt. Derwent Wood, a sculptor in peacetime, devised the first
modern facial prostheses. As he explained in an article written for the medical
journal *Lancet*: "My work begins when the work of the surgeon is completed.
When the surgeon has done all he can to restore function, to heal wounds,
to support flesh tissues by bone grafting, to cover areas by skin grafting, I
endeavour by means of the skill I happen to possess as a sculptor to make a
man's face as near as possible to what it looked like before he was wounded."[23]

In late 1917, the American Red Cross established a Studio for Portrait
Masks on the Left Bank in Paris. The studio was conceived, created, and
directed by a novelist and sculptor from Boston named Anna Coleman Ladd,
who was commissioned by the Red Cross to execute her plan. From a work-
shop in the artists' quarter, Ladd and her team created a total of ninety-
seven life masks during their eleven months in operation. That amounts to
approximately nine masks per month, a high degree of productivity for such
a small, labor-intensive workshop (Fig. 33). And yet, for all of that, the num-
ber seemed woefully inadequate. Industrialized modern warfare was pro-

Figure 33. Trying on a mask before it has been painted, 1918. Library of Congress.

ducing deformities on a scale well beyond the recuperative means of nineteenth-century-style artisanship. To borrow a phrase from Ellen La Motte, an American nurse and journalist who served at the front, "the science of healing stood baffled before the science of destroying."[24]

Nonetheless, Ladd and her colleagues pressed ahead. They understood their job to be more than that of creating masks so lifelike as to be virtually invisible. They sought also to help the newly masked regain a sense of dignity. To that end, the Left Bank studio was designed as a warm and inviting place, where *les gueules cassées* who came in for fittings could feel pleasantly at home.

Figure 34. Soldier with mutilated face protected
by one of Anna Coleman Ladd's masks, 1918. Library
of Congress.

Previously, when these broken-faced men had gone on supervised for-
ays into the city accompanied by their nurses, onlookers gawked at them
and sometimes even fainted. The men called this the Medusa effect. Sup-
plied now with tin and copper masks, they could—in theory, at least—walk
down a Parisian boulevard without even eliciting stares (Fig. 34). After
the war, Ladd proudly asserted that "many of these soldiers have returned
back to wife, children or family, slipping back into their former places in
society, able to work and derive a bit of happiness out of life." One cannot
help but wonder if she was overly optimistic about their chances for social

reintegration. I think instead of those melancholy lines from T. S. Eliot's *The Waste Land:* "I could not / Speak, and my eyes failed, I was neither / Living nor dead, and I knew nothing." Or as Richard III laments, "I, that am rudely stamped and want love's majesty . . . dogs bark at me as I halt by them."[25]

A four-minute silent film made by the American Red Cross, available on YouTube, shows Ladd, garbed in a Red Cross military uniform, as she puts finishing touches on her masks and fits them onto wearers, each of whom bears a row of medals on his chest. One soldier with a prosthetic chin puffs jauntily on a cigarette, demonstrating the versatility of the contraption strapped to his face. Another, whose wound is not identifiable, sports a classically rugged jaw. An assistant with a fine-tipped paintbrush fills in the false moustache that artfully disguises the seam between mask and face.

A third soldier looks perfectly natural until his mask is removed for minor readjustments, and we see that he has lost his nose. An instant later the mask is reattached, held in place by eyeglass frames secured around his ears, and the patient resumes his conventionally handsome appearance. Looking on, Ladd smiles benevolently.[26]

"The overriding principle was that of a return to normality," notes the scholar Claudine Mitchell. The purpose of the plastic surgeons and mask-makers was that "The mutilated would smoothly fall back into the social space they had occupied before the war, that of work and family." Unfortunately, when the war ended, convalescents were quickly discharged from military hospitals, and public funding for the continuation of costly facial surgery disappeared. The portrait mask studios were disbanded.[27]

Nonetheless, a sea change had been wrought. Masking, by way of cosmetic surgery or cosmetic makeup, rapidly gained ground as a legitimate form of therapeutic behavior. If modern techniques of appearance alteration were suitable for wounded soldiers, why shouldn't everyone, maimed or otherwise, enjoy their benefits? Face lifts, nose jobs, chin tucks, and, further down the map of the body, breast augmentations, breast reductions, and the

reshaping of calves were now increasingly taken to be improvements not only of the individual who underwent them but of the body politic itself.

+ + + +

And nowhere was this more the case than in the United States. Between the end of the First World War and beginning of the Second, there were only four full-time plastic surgeons in Great Britain but sixty in the United States.[28] Why would postwar Americans have embraced cosmetic surgery more ardently than did their counterparts in Europe? Perhaps Europeans, routinely encountering evidence of plastic surgery's inability to make shattered faces whole again, lacked the Americans' optimistic faith in the power of the surgical blade to restore health and beauty. Moreover, America itself had been founded on principles of self-invention and self-revision, of forsaking the old in search of the new and leaving behind the encumbrances of the past, including those of the sick, aging, or unattractive body. Ivan Albright's contrarian view took him in the opposite direction; instead of idealizing his attractive young model Ida Rogers on canvas, he made her old and time-ravaged, her body as badly pocked and cratered as No Man's Land, as if to protest the can-do, anything-is-possible, make-yourself-new youth fetish of the booming twenties.

But as noted above, this current in American thinking goes back well before the twenties. And it extends well into today. From Ralph Waldo Emerson in the 1840s ("All life is an experiment. The more experiments you make the better") to the motivational speaker Zig Ziglar in the 2000s ("Building a better you is the first step to building a better America"), Americans have extolled the gospel of self-renewal. Plasticity, or the quality of being flexible and open to change, is an integral quality for a nation that has regarded itself from the start as mankind's "great experiment" in democratic governance.[29]

The modifier "plastic" comes from the Greek word *plastikos*, meaning to form, mold, or sculpt, and hence it was an appropriate way of describing

the complex medical procedures required to reshape the face. At the same time this word entered the medical lexicon, it acquired a more extensive cultural and industrial meaning. Percy Marks's best-selling novel *The Plastic Age* told a coming-of-age (hence "plastic") tale of college life, where "flaming youth," in rebellion against the conservative rigidities of an earlier generation, partied and petted to excess. Hollywood's adaptation of the book, released in 1925, made a star of a baby-faced actress named Clara Bow. Provocatively wild onscreen as well as off, she was dubbed the "It Girl" (or as a Freudian might have said, id girl) of the Jazz Age. Bow's face was remarkably plastic, always changing with every ripple of mood that passed across her brow; in this, hers was the antithesis of Garbo's inelastic face, which looked to be carved from marble.[30]

Also in the mid-twenties a synthetic compound called plastic swept American industrial design. Introduced in the 1850s, celluloid, a vegetable-based plastic, had relatively limited use in the manufacture of shirt collars, buttons, visors, and, in the early twentieth century, film stock. The first fully synthetic plastic, Bakelite, patented in 1907, extended the manufacturing range of the compound, but it was thanks to intensive chemical research pursued under the aegis of World War I that new, resilient forms of plastic became widely available, offering unlimited possibilities for the cheap and semi-durable manufacture of consumer goods. Previously, designers were compelled to work from solid substances such as wood, metal, stone, and glass, but now, according to one enthusiast, "From all these limitations, imposed by the nature of materials, the designer is now free. Plastics have given him a new and almost unbelievable liberty for experiment and expression." Noting the ferment, change, and tireless self-reinvention of Americans on multiple levels during the dozen or so years from the Great War to the Great Depression, the historian Robert Sklar referred to the period as "The Plastic Age."[31]

Cosmetic surgery, loftily renamed aesthetic surgery, was a subset of plastic

surgery. As cosmetic surgery gained credibility, so too did the use of cosmetic makeup. During the previous century, the application of makeup by typical women—as opposed to actresses and prostitutes—was frowned on. Americans associated makeup with falsehood, insincerity, vanity, and deception, as exemplified by John Singer Sargent's notorious 1884 portrait of a heavily made-up society woman discreetly identified as "Madame X." Thus American women were caught in a double bind: society expected them to be fetching and pretty, especially when young, but to be so "naturally," without providing any telltale evidence of having put their minds to it. Beauty was expected to spring from within, an emanation of spiritual harmony. Those who manipulated their appearance with cosmetics were deemed "painted women" and likened to the Biblical idolatress Jezebel, a figure of ill repute. Even though women wore makeup throughout these years, the expectation was that they do so modestly and inconspicuously, without calling attention to the home-brewed or locally prepared "complexion remedies" that they employed.[32]

The dubious morality of women who wore makeup was the theme of filmmaker D. W. Griffith's postwar melodrama *True Heart Susie*. Lillian Gish, playing a rosy-cheeked, small-town lass, refuses to wear makeup and modern styles of clothing because they are meant to deceive (Fig. 35). Her beau is almost snatched away from her by a seductress who uses makeup and sexy apparel to catch his attention. A title card decries the situation: "Do men look for the true heart in women? Or are most of them caught by the net of paint, powder and suggestive clothes?" Gish retaliates by prettying herself up, but not to the extent of masking her true self, as the other woman had done. Another title card specifically invokes military terminology by characterizing makeup as the artillery a woman uses for laying siege to the heart of a man.

An artist of multiple self-contradictions, Griffith rails against makeup from his position as a conservative, moralistic, antiurban, antifeminist, antimodern, neo-Victorian. And yet, as a former stage actor and ongoing

Fixing Faces

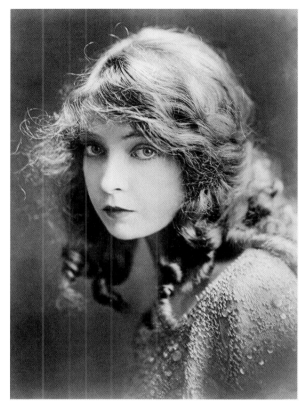

Figure 35. Lillian Gish, star of *True Heart Susie*, dir. D. W. Griffith, 1919.

cinematic innovator who continually thirsted for commercial success, he also valued makeup ("grease paint"; "war paint") for its rhetorical power. At no point during *True Heart Susie* does Lillian Gish appear onscreen *without* makeup, even though the movie takes a stand against the vanity that its usage is said to imply.

On a more direct level, World War I contributed to the American makeup

Fixing Faces

revolution by driving the Polish-Jewish beauty-entrepreneur Helena Rubinstein away from her home in Paris to the safe haven of New York. Rubinstein was despondent at having to leave France for America, fearing the demise of her lucrative beauty-salon business. As she motored down Fifth Avenue, however, and observed the pale faces and gray lips of female pedestrians, her mood lifted. She saw stretching before her a virgin continent of women who had yet to be introduced to the charms of wearing makeup. "So, I said to myself," she recounts in her autobiography, "here is not only a new country but a huge new market for my products."[33]

Rubinstein played to the desire of postwar American women to indulge themselves, by way of daily makeup rituals, in "foreign" intrigue and exoticism, be it European or Middle Eastern in nature. One of Rubinstein's most famous clients was the silent screen star Theda Bara, formerly Cincinnati's Theodosia Goodman, the daughter of a Jewish immigrant tailor. Studio publicists reinvented her as the Cairo-born daughter of a French sculptor and an Arabian princess.

Both Rubinstein and her rival, Elizabeth Arden, discreetly provided in-house face lifts and nose jobs. Arden was herself a friend and confidante of Sir Harold Gillies, who performed skin peels for members of her circle, including the pioneering American interior decorator Elsie de Wolfe, who had won a Croix de Guerre and a Legion of Honor medal for her nursing efforts with gas-burn victims in France during the war. But most customers were satisfied with the less painful and less costly, if also less effective, treatment afforded by the application of a so-called "beauty masque," in which a woman's face was thoroughly covered for several hours with therapeutic mud or steamed and aromatized cloth bandages. Rubinstein in particular was drawn to the mask aesthetic. An avid art collector, she assembled a world-class collection of African face masks.[34]

+ + + +

Modernists were infatuated with masks. In the late nineteenth century, aesthetes such as Algernon Charles Swinburne, James McNeill Whistler, and Oscar Wilde had advocated, and in their own lives embodied, artificiality in personal appearance. Wilde, for instance, praised "the truth of masks," claiming that "a mask tells us more than a face" and "Man is least himself when he talks in his own person. Give him a mask, and he will tell you the truth." Elsewhere, he announced, "The first duty in life is to be as artificial as possible," and he added, "What the second duty is no one has as yet discovered." Friedrich Nietzsche declared in *Beyond Good and Evil* that "Every profound spirit needs a mask."[35]

Early in the twentieth century, the proto-modernists' praise of metaphorical masks turned into an obsession with literal ones. Proudly displayed in ethnographic museums in Paris, Berlin, and other European capitals enriched by African colonization, tribal face masks caught the attention of avant-garde artists because they seemed so shockingly *primitive* and otherworldly. With their exaggerated and violent forms, they were the antithesis of the conventional realist art favored by the bourgeoisie. In 1907 Pablo Picasso included African masks in his designs for *Les Demoiselles d'Avignon*, and in 1908 the innovative British theatre director Gordon Craig began publishing a journal entitled *The Mask*, which celebrated theatrical artifice and attacked naturalistic representation ("It is this sense of beyond reality which permeates all great art"). In these same prewar years, Igor Stravinsky in music, Sergei Diaghilev in dance, and Luigi Pirandello in drama shared the aesthetic fascination with masks for their potential to disrupt settled ways of thinking and feeling.[36]

The more emphatic and devastating disruption of the war having come and gone, the modernist fascination with masks continued to grow. Writes Walter Sorell, "After the First World War, when all the old values collapsed with the empires and traditional ideas, the search went on for the forgotten primitive forms and sources which were resurrected in basic modern dance,

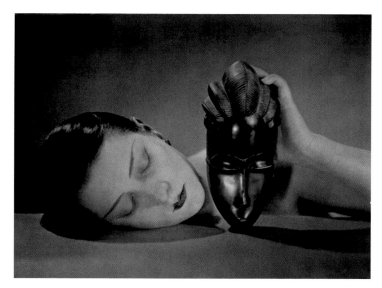

Figure 36. Man Ray, *Noire et blanche (Black and White)*, 1926. Gelatin silver print, 6¾ × 8⅞ in. (17.1 × 22.5 cm). Museum of Modern Art.

in the volcanic stammering cries of Expressionistic despair, in the Dadaistic fury of self-defiance, and in phantasmagoric Surrealism with its glazing of Freudian imagery." In sum, "The mask returned, reflecting and revealing the savage instincts of man let loose again, the old demonic spirits in new clothing, the spirits man feared and tried to escape while falling prey to them."[37]

Surrealist poets, painters, and photographers regarded masks as a doorway to the instinctual realm of dreams, fantasies, and hidden desires. Man Ray's 1926 photograph *Noire et blanche* (or *Black and White*) juxtaposes the heavily made-up face of his lover, Kiki of Montparnasse, with an ebony face mask (Fig. 36). The composition and lighting oppose her European whiteness to the mask's African blackness but also suggest similarities and overlap between them. Her moist black hair gleams with white highlights, as does

the mask, and both faces cast oblong shadows that spill across the neutral gray tabletop on which they rest. With her eyes closed, the woman appears to be asleep. Is the mask she holds upright in her hand an indication of the "primitive" dream state that resides within her, or is it instead an expression of the reified existence, the "false front" social armor, that she is only able to shed while in a state of profound slumber?

Helena Rubinstein's husband at the time, Edward Titus, a denizen of the Montparnasse café scene, privately published an English translation of Kiki's memoirs, with full-page photographs of her by Man Ray and others, including *Noire et blanche*. In his introduction to the book, Ernest Hemingway writes of the model, "She was wonderful to look at. Having a fine face to start with, she had made of it a work of art." On publication in New York, the book was banned by the United States government on grounds of obscenity, as several of the pictures of Kiki were in the nude.[38]

Another memorable surrealist photograph that plays on the notion of masking is Edward Weston's *Civilian Defense* (Fig. 37). Made in early 1942, shortly after the United States had returned to a state of war, it shows a naked model stretched out on a divan. She looks like a nineteenth-century academic nude framed by palm fronds, except that she happens to be wearing a gas mask. The absurd juxtaposition of female flesh and inorganic military materials is meant to be humorous or shocking or both.

On one level, Weston may be having fun with Picasso, whose 1939–40 retrospective show at the Museum of Modern Art attracted an unprecedented fifteen thousand visitors a week and made him the most famous modern artist in the world. The exhibition ended with violently aggressive portraits of his mistress Dora Maar that combined traditional figurative drawing with cubist and surrealist pictorial techniques. These gave the beautiful young model an alien countenance, almost as if she were wearing a facial prosthesis or even a mechanical attachment, such as a gas mask. According to the Picasso historian Palomar Alarcó, "The last works on dis-

Fixing Faces

Figure 37. Edward Weston, *Civilian Defense*, 1942, printed 1953/54. Gelatin silver print, 7⁵/₈ × 9¹/₂ in. (19.3 × 24.3 cm). The Art Institute of Chicago.

play were *Guernica*, which Picasso had lent for the occasion, and various por-
traits of Dora Maar, all examples of the impact on his art of the horrors of
war. Dora's emotional instability allowed the artist to symbolize the insta-
bility of the world through her image, which Picasso subjected to an extreme
degree of distortion . . . expressing the anguish of war."[39] Weston's *Civilian
Defense* is clearly playful in tone, not an expression of the anguish of war, but
it does seek nonetheless to make war ridiculous, as absurd as an odalisque
wearing a gas mask.

The photograph throws together signifiers of beauty and barbarity. In
doing so it confounds gender categories, for the model's body is clearly fem-
inine, but her face is clad in that quintessential modern symbol of masculine
military might, the gas mask. Gas masks had been invented before the First

Fixing Faces

Figure 38. Otto Dix, *Assault Troops Advance under Gas*, 1924. Etching and aquatint, 7⁹/₁₆ × 11³/₁₆ in. (19.2 × 28.4 cm). Harvard University Art Museums.

World War, but they only came into widespread use after the first chlorine gas attack, which the Germans launched in April 1915 at the Second Battle of Ypres. After that, breathing masks were standard issue on the western front. Making the humans who wore them appear inhuman, gas masks entered the public consciousness as icons par excellence of the brutal, self-alienating aspects of war in the modern era. Their fearsomeness is best conveyed by Otto Dix's 1924 etching and aquatint, *Assault Troops Advance under Gas* (Fig. 38).

What was it about masks, whether ritualistic and tribal or military and mechanical, that cast a spell on so many modern artists? Perhaps it had to do with a shared conviction that in bourgeois society everyone wears a mask anyway. Social science and its offshoots seemed to confirm this

view. Freud and Jung, for example, asserted that common, ordinary individuals were weighed down by internal masks that they themselves were little equipped to recognize and remove. In 1929 Freud's British translator Joan Riviere, a psychoanalyst and feminist, observed that the more women advance socially and politically, the greater their need to reassure men, thereby staging a daily "masquerade" of femininity that requires rituals of facial adornment.[40]

Popular culture also evinced a heightened fascination with masks and masking. In *The Mark of Zorro* (1920), Douglas Fairbanks became the most popular leading man of the day as the legendary masked swordsman. Masked balls were in vogue. The centenary of Beethoven's death in 1927 produced a new interest in death masks of the great and famous, but perhaps the most celebrated one of the era was the so-called *Inconnue de la Seine,* supposedly made by Parisian morgue workers from the beatific face of an unidentified girl who had flung herself into the river after being spurned in love. "During the 1920s and early 1930s," writes A. Alvarez, "nearly every student of sensibility had a plaster cast of her death mask." According to Walter Sorell, writing some half a century later, the mask's replica, copied into the thousands, could "be seen on the shelves and in the windows of shops selling artist's materials as a tempting invitation to draw or sculpt a version of this strange, angelic-looking face." He adds, "For years I had the mask hanging on the wall above my desk. I must have gained some comfort in gazing at it, some reassurance of a less frightening aspect of death." Not least, the newly revived Ku Klux Klan, which surged in popularity during the twenties, made white hoods—a sort of all-over face mask—into a much-feared, but also revered, sign of racial superiority. In *The Jazz Singer* (1927), the first motion picture with fully synchronized sound, Al Jolson famously performed the number "My Mammy" in blackface—yet another type of mask. To be sure, African American artists and intellectuals of the Harlem Renaissance were already critically conversant with the notion of race

as a mask or construct, as expressed in Paul Laurence Dunbar's canonical poem of a quarter of a century earlier lamenting the need for black people to "wear the mask that grins and lies" in order to appease dominant white culture.[41]

In other words, moderns were fascinated by masks and recognized their potential both for evil and for good. Tribal masks might seem curious and strange and gas masks at once terrifying and ludicrous, but nothing was worse than those invisible masks inside that alienated individuals both from others and from themselves. Then again, gas masks were able to protect soldiers from toxic vapors, tin masks could allow broken-faced veterans to reenter society, cosmetic surgery could help patients gain or regain their sense of self-worth, and even well-applied makeup could give women increased self-confidence in public. Indeed, American women fully embraced the mask aesthetic every time they put on their mascara, which was first mass-produced and mass-marketed in 1917, not knowing, perhaps, that the term for brushed-on eyelash thickener comes from the Italian word *maschera,* or mask.

If at the end of the First World War, conservative Americans such as D. W. Griffith decried the use of makeup, scorning it as nothing more than "artillery" in the battle of the sexes, by the start of the Second World War, wearing makeup was considered patriotic for America's females. It was seen as a way to boost their morale during a period of anxiety and privation, as well as to motivate millions of men who once again sallied across the seas to protect their women from foreign invasion. The government went so far as to decree the manufacture of lipstick a wartime necessity, but that changed with the military's increased demand for the oil used in lipstick production. The reddening of lips declined in America, but only temporarily, until peace was restored.[42]

+ + + +

Let us return now to Greta Garbo. As noted earlier, the legendary beauty was renowned for her mask-like features and fixed countenance. Many attempts, including those quoted above, have been made to explain her magnetic power over viewers. Perhaps the best known of these is "The Face of Garbo," an essay written in the early 1950s by the French literary critic Roland Barthes in his studies of modern-day "mythologies."

Barthes argues that Garbo's face was an "absolute mask" that "offered to one's gaze a sort of Platonic Idea of the human creature." Her visage, he writes, "has the snowy thickness of a mask: it is not a painted face, but one set in plaster." This calls to mind Hemingway's description of *les gueules cassées*, the Great War veterans whose surgically reconstructed faces had the texture and density of "a well-packed ski run." According to Barthes, what made the face of Garbo so compelling to watch was that, "Amid all this snow at once fragile and compact, the eyes alone, black like strange soft flesh . . . are two faintly tremulous wounds." Or as the German art theorist and film writer Rudolph Arnheim, an enthralled follower of Garbo, wrote in 1928, "We see through the darkly shadowed eyes as though we were gazing miles-deep into the interior of a crater." The power of Garbo's face, and the reason it created such a frisson for viewers, is that it was simultaneously hard, cold, and rigid but also throbbing with life, pain, and yearning.[43]

Studying the sculpted countenance of Greta Garbo, one is also reminded of the tin and copper masks provided by the likes of Anna Coleman Ladd. Rigid, sculptural, mechanical, these masks, too, like Garbo's face, were Platonic artifacts, attesting to idealized, socially sanctioned conceptions of gender-appropriate beauty. The inescapable evidence of life and feeling pulsating beneath the frozen immobility of her flawless features made Garbo's face hypnotically compelling. What must have made the masked men, on the other hand, so awful to encounter on the street or in a streetcar was that same dialectic between stasis and movement, hardness and softness, death-like perfection and lifelike pain.

Figure 39. Lon Chaney in *The Phantom of the Opera*, 1925.

Only here their counterpart in the silent cinema was not Greta Garbo with her mask of perfection but rather that great pathetic movie monster, the Phantom of the Opera (Fig. 39). The sudden revelation of the Phantom's badly disfigured face two-thirds of the way into the 1925 thriller named for him was horrifying to silent-era audiences, but not as dreadful, surely, as the long, slow buildup to that climax, when they were forced to imagine what *might* lurk beneath his mask.

Garbo's exceptional beauty, it should now be noted, was carefully constructed at the behest of her studio, MGM. The makeup artists, hair stylists, and hair colorists assigned to her were the best in the business, as were her cinematographer and lighting specialists. She also secretly engaged in a series of surgical interventions to remove incipient wrinkles, widen her eyes, and reshape her nose. In this regard, she was the antithesis of Ida Rogers (see Fig. 32), the pretty young model for Ivan Albright who was trans-

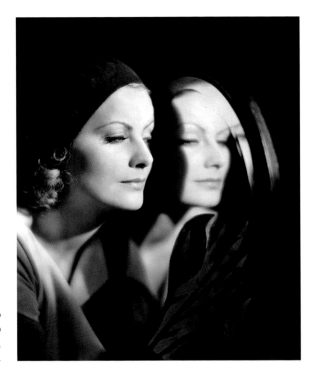

Figure 40. Greta Garbo in *The Kiss*, 1929 (Clarence Sinclair Bull, photographer).

formed through his creative artifice in the opposite direction, made into a pitiful signifier of decrepitude. Not Garbo (Fig. 40). According to one historian: "Her hairline was evened out, her nose seems to be made narrower and her lips were sloped differently. The studios worked with cosmetic surgeons and employed a dentist full-time to correct the star's teeth. Garbo's previously dark and crooked teeth were capped. [She] was thus brought into line with an existing ideal of beauty."[44]

Garbo's face, with its smooth, clean, aerodynamic lines and symmetrical shapes, was Art Deco with soul, mechanization with heart. It offered audiences, locked in the darkness of the silent cinema and eager to escape

Fixing Faces

Figure 41. Greta Garbo in *Anna Christie*, 1930. 8 × 10 in (20.32 × 25.4 cm). MGM / The Kobal Collection / Art Resource.

the harsh light of postwar reality, a fleeting glimpse of perfection, of stain-less-steel smoothness and strength, but tempered with humanizing melan-choly (Fig. 41). Perhaps, as discussed earlier in this chapter, they sensed that beyond the Platonic harmonies of her face, in the depths of her mournful eyes, seethed a grief that was not hers alone, but shared by millions every-where who had recently emerged from the abyss of war, shaken and scathed.

+ + + +

In and of itself, the First World War did not cause the modern beauty revo-lution. That was already underway when it began. But the war accelerated

the transformation by leading directly to the development of cosmetic plastic surgery and medical facial prostheses and indirectly to the widespread use of commercial makeup and other industrially produced technologies for the adornment of the female face. Masks of one form or another proliferated. Overwhelming onlookers with its unprecedented carnage and haunting their dreams with maimed and unsightly survivors, the war drove peacetime populations into a compulsive search for physical beauty. In the face of ugliness, beauty was redefined.

CHAPTER ONE. ART FOR WAR'S SAKE

1. George Creel, *How We Advertised America: The First Telling of the Amazing Story of the Committee on Public Information that Carried the Gospel of Americanism to Every Corner of the Globe* (New York: Harper & Brothers, 1920; rpt. New York: Arno Press, 1972).

2. David M. Kennedy, *Over Here: The First World War and American Society*, 25th anniversary edition (New York: Oxford University Press, 2004), 76–78.

3. Barbara S. Kraft, *The Peace Ship: Henry Ford's Pacifist Adventure in the First World War* (New York: Macmillan, 1978). On McCay, see Donald Crafton, *Before Mickey: The Animated Film 1898–1928* (Cambridge, MA: MIT Press, 1982), 116–17. The video is available on DVD and YouTube.

4. Ilene Susan Fort, *The Flag Paintings of Childe Hassam* (Los Angeles: Los Angeles County Museum of Art, 1988), 9–10. See also H. Barbara Weinberg et al., *Childe Hassam: American Impressionist* (New York: Metropolitan Museum of Art, 2004), 216–26.

5. See Rebecca Zurier, *Art for the "Masses": A Radical Magazine and Its Graphics* (Philadelphia: Temple University Press, 1988), for a thorough discussion of the art program for this publication, and William O'Neill, ed., *Echoes of Revolt: "The Masses," 1911–1917* (New York: Quadrangle Books, 1966). See also Richard Fitzgerald, *Art and Politics: Cartoonists of the "Masses" and "Liberator"* (Westport, CT:

Greenwood Press, 1973). Zurier's *Picturing the City: Urban Vision and the Ashcan School* (Berkeley and Los Angeles: University of California Press, 2006) provides in-depth analysis of the visual and political worlds of the Ashcan artists.

6. Mike Moser, "When Jesus Was Left: Christians, Socialists, and the Masses," in *Bad Subjects* 72 (February 2005), http://bad.eserver.org/issues/2005/72/mosher.html. For a comprehensive view of Bellows's careers as an artist, see Charles Brock et al., *George Bellows* (Washington, DC: National Gallery of Art, 2012).

7. See, for example, *New York Times*, May 9, 1917, 12, "Marshal Joffre Due Here Today," with its subheadings, "The City Gay with Colors" and "Thousands of Buildings Draped with Flags of United States, Britain, and France"; May 10, 1917, 3, "Flags Bedeck City as If for Victory: Fifth Avenue and Broadway a Marvelous Mass of Flaunting Colors."

8. Fort, *Flag Paintings of Childe Hassam*, 109; for greater detail on this topic, see Elizabeth Broun, "Hassam's Pride in His Ancestry," in Weinberg et al., *Childe Hassam*, 285–94.

9. See Patricia Junker, "Childe Hassam, Marsden Hartley, and the Spirit of 1916," *American Art* 24, no. 3 (Fall 2010): 26–51.

10. Both quoted in Philip S. Foner, *History of the Labor Movement in the United States*, vol. VII, *Labor and World War I, 1914–1918* (New York: International Publishers, 1947), 68.

11. The literature on Mooney and Billings is extensive; see, for example, Henry Thomas Hunt, *The Case of Thomas J. Mooney and Warren K. Billings* (1929, rpt. New York: Da Capo Press, 1971) and Curt Gentry, *Frame-Up: The Incredible Case of Tom Mooney and Warren Billings* (New York: Norton, 1967).

12. Harold D. Lasswell, "The Garrison State," *American Journal of Sociology* 46, no. 4 (January 1941): 455–68, reprinted in Lasswell, *On Political Sociology*, ed. Dwaine Marvick (Chicago: University of Chicago Press, 1977), 165–76.

13. Henry L. Stimson and MacGeorge Bundy, *On Active Service in Peace and War* (New York: Harper, 1948), 624–33, which quotes at length from "The Decision to Use the Atomic Bomb," Stimson's article in *Harper's Magazine* (February 1947), 97–107, providing his justification for the nuclear assault on Japan. See Geoffrey Hodgson, *The Colonel: The Life and Times of Henry Stimson, 1867–1950* (New York: Knopf, 1990), esp. 330–32, and Sean L. Malloy, *Atomic Tragedy: Henry L. Stimson*

and the Decision to Use the Bomb against Japan (Ithaca, NY: Cornell University Press, 2008).

14. The best studies of this topic are Pearl James, "Images of Femininity in American World War I Posters," in James, ed., *Picture This: World War I Posters and Visual Culture* (Lincoln: University of Nebraska Press, 2009), 273–311; Anne Classen Knutson, "Breasts, Brawn and Selling a War: American World War I Propaganda Posters 1917–1918," PhD diss., University of Pittsburgh, 1997 (Ann Arbor, MI: University Microfilms International, 1998); and Celia Malone Kingsbury, *For Home and Country: World War I Propaganda on the Home Front* (Lincoln: University of Nebraska Press, 2010), esp. chap. 5, "The Hun Is at the Gate: Protecting the Innocents," 218–61.

15. Ernest Haskell, "Introduction," in *Childe Hassam*, comp. Nathaniel Pousette-Dart (New York: Frederick A. Stokes, 1922), vii. Quoted in Ilene Susan Fort, *Childe Hassam's New York* (San Francisco: Pomegranate Artbooks, 1993), n.p.

16. See Glenn Watkins, *Proof through the Night: Music and the Great War* (Berkeley and Los Angeles: University of California Press, 2002), which provides a rich cultural history of European and American music during the war years.

17. Robert Justin Goldstein, *Saving "Old Glory": The History of the American Flag Desecration Controversy* (Boulder, CO: Westview Press, 1994), 73, citing S. S. Condo, *Our Flag and the Red Flag* (Marion, IN: S. S. Condo, 1915), 9–10, 13, 15–16.

18. Maurice Becker, "Patriotism," *Masses* 8, no. 6 (April 1916): 10, and Zurier, *Art for the* Masses, 176.

19. See the detailed account in Jay Feldman, *Manufacturing Hysteria: A History of Scapegoating, Surveillance, and Secrecy in Modern America* (New York: Pantheon, 2011).

20. W. J. Gordon, *Flags of the World, Past and Present: Their Story and Associations* (London: F. Warne, 1915), 1.

21. John P. Diggins introduces the term Lyrical Left in *The American Left in the Twentieth Century* (New York: Harcourt Brace Jovanovich, 1973), 7, 17, and 74, adapting it from Floyd Dell's use of the term Lyrical Year in his euphoric recollections of the period; Dell, in turn, references a 1912 poetry anthology called *The Lyric Year*, which contained Edna St. Vincent Millay's prize-winning poem "Renascence." See *The Lyric Year: One Hundred Poems*, ed. Ferdinand Earle (New York: Mitchell Kennerly, 1912), and Floyd Dell, *Homecoming: An Autobiography*

(New York: Farrar & Rinehart, 1933), 218. Other classic accounts of this period include Van Wyck Brooks, *America's Coming-of-Age* (New York: B. W. Huebsch, 1915) and *An Autobiography* (New York: E. P. Dutton, 1965); Henry Farnham May, *The End of American Innocence: A Study of the First Years of Our Own Time, 1912-1917* (New York: Knopf, 1959); and Arthur Frank Wertheim, *The New York Little Renaissance* (New York: NYU Press, 1976). See also Edward Abrahams, *The Lyrical Left: Randolph Bourne, Alfred Stieglitz, and the Origins of Cultural Radicalism in America* (Charlottesville: University of Virginia Press, 1986).

22. See Edward Steichen, *A Life in Photography* (Garden City, NY: Doubleday, 1963), n.p., chap. 3 (second and third pages after plate 28), and Jean Strouse, *Morgan: American Financier* (New York: Random House, 1999), 650-51.

23. Glyn Davis, "Photography and Film," in *Exploring Visual Culture: Definitions, Concepts, Contexts*, ed. Matthew Rampley (Edinburgh: Edinburgh University Press, 2005), 91-92.

24. Strand interviewed by Calvin Tomkins, June 30, 1973, as quoted in Maria Morris Hambourg, *Paul Strand, circa 1916* (New York: Metropolitan Museum of Art, 1998), 28-29. Six years after taking *Wall Street*, Strand re-created it in motion-picture form when he and fellow artist Charles Sheeler collaborated on an avant-garde documentary film entitled *Manhatta* (1921).

25. Hambourg, 29, quoting letter from Strand to Walter Rosenblum, May 21, 1951.

26. Jotham Sederstrom, "J. P. Morgan's Fortress, Long Vacant, Looks for Upscale Tenants," *New York Times*, August 24, 2011, B-9; Ron Chernow, *The House of Morgan: An American Banking Dynasty and the Rise of Modern Finance* (New York: Atlantic Monthly Press, 1990); Lewis Corey, *The House of Morgan: A Social Biography of the Masters of Money* (New York: G. H. Watt, 1930); Edwin P. Hoyt, Jr., *The House of Morgan* (New York: Dodd, Mead, 1966).

27. See Thomas A. Bailey and Paul B. Ryan, *The Lusitania Disaster: An Episode in Modern Warfare and Diplomacy* (New York: Free Press, 1975), 96-102, 165-66, and 178, and Colin Simpson, *The Lusitania* (Boston: Little, Brown, 1973), 157-58.

28. Zechariah Chafee, Jr., *Free Speech in the United States* (Cambridge, MA: Harvard University Press, 1941), 74-75, n10. Chafee, on 79, reports that under the Espionage Act: "Our judges condemned at least eleven persons to prison for

ten years, six for fifteen years, and twenty-four for twenty years." See Kennedy, *Over Here*, 78–79.

29. For a vivid description of the affair, see Chernow, *House of Morgan*, 212–14.

30. Randolph Bourne, "Below the Battle," *Seven Arts Chronicle* 2 (July 1917): 270–77, first reprinted in Bourne, *Untimely Papers*, ed. James Oppenheim (New York: B. W. Huebsch, 1919), 47–60.

31. Important studies of American advertising in historical context include Stephen R. Fox, *The Mirror Makers: A History of American Advertising and Its Creators* (New York: Morrow, 1984); T. J. Jackson Lears, *Fables of Abundance: A Cultural History of Advertising in America* (New York: Basic Books, 1994); Roland Marchand, *Advertising the American Dream: Making Way for Modernity, 1920–1940* (Berkeley and Los Angeles: University of California Press, 1985); and Michael Schudson, *Advertising, the Uneasy Persuasion: Its Dubious Impact on American Society* (New York: Basic Books, 1984).

32. Figures from *New York Times Magazine*, March 10, 1918, cited in Wikipedia entry for "Liberty Bond."

33. Walton Rawls, *Wake Up America!: World War I and the American Poster* (New York: Abbeville Press, 1988), 226. Pennell himself offers a history of this poster and its reception in *Joseph Pennell's Liberty Loan Poster: A Text-Book for Artists and Amateurs, Governments and Teachers and Printers* (Philadelphia: Lippincott, 1918; currently available in print-on-demand edition).

34. "Childe Hassam Arrested; Policeman Congratulated by Artist for His Alertness in Riverside Park," *New York Times*, April 17, 1918, 24. See Hassam's lithograph *Camouflage* (1918, New York Public Library) in Elizabeth E. Barker, " 'A truly learned weaving of light and dark': Hassam's Prints," in Weinberg et al., *Childe Hassam*, 277.

35. These location specifics emerged during the course of a five-way email exchange I enjoyed in August 2011 with art museum curators Anne Knutson, Barbara Weinberg, and Sylvia Yount and the architectural historian and licensed New York City guide Matt Postal. Fort, *Flag Paintings of Childe Hassam*, 102, notes that this is the only one of Hassam's flag paintings to include a sweeping vista and rooftops. It is also one of the only ones in the series to depict a still, almost furled flag.

CHAPTER TWO. FIXING FACES

1. Edward Steichen, *A Life in Photography* (Garden City, NY: Doubleday, 1963), n.p., chap. 8 (page following plate 112); Penelope Niven, *Steichen: A Biography* (New York: Clarkson Potter, 1997), 515. Steichen misremembers the title of the film as *The Green Hat*, which was the name of Michael Arlen's bestselling novel on which the movie, *A Woman of Affairs* (1928), was based; the scene in question begins approximately thirty minutes into the film (chap. 7 on the MGM home video laser disc). In their excellent study of studio glamour photography in the 1920s, Robert Dance and Bruce Robertson claim that Steichen did more than misremember the title of the film—they contend he also distorted or reported incorrectly a number of other details, including the scene on which Garbo was working, the amount of time allocated to the shoot, the hairstyle she was wearing, and the originality of the hands-to-head gesture, which had already become a familiar Garbo motif. See Dance and Robertson, *Ruth Harriet Louise and Hollywood Glamour Photography* (Berkeley and Los Angeles: University of California Press, 2002), 177–79.

2. Klaus-Jürgen Sembach, "Greta Garbo," in *Greta Garbo: Portraits 1920–1951*, trans. Sonja Hauser, ed. Dee Pattee (New York: Rizzoli, 1986), 7.

3. On glamour as a culturally specific phenomenon, see Judith Brown, *Glamour in Six Dimensions: Modernism and Radiance of Form* (Ithaca, NY: Cornell University Press, 2009); Carol Dyhouse, *Glamour: Women, History, Feminism* (New York: Zed Books, 2010); and the aforementioned Dance and Robertson, *Ruth Harriet Louise*, especially the chapter on Garbo and her photographers, 157–84. According to Brown, on 101–02, "Garbo's power rested, at least partially, in the lunar quality of her skin, the glow that erased the human detail and staged the tremendous and ethereal vitality of her eyes. No one better understood this than the generation of glamour photographers who worked in the studio system of Hollywood. Glamour photography, emerging in the 1920s and reaching its apex in the 1930s, was explicitly designed to produce the celebrity as beyond human, as intangible as light."

4. Niven, *Steichen*, 466; Steichen, *A Life in Photography*, chap. 5 (fourth page following plate 62); the quotation in the following paragraph ("I could not deny to myself . . . ") is also from this page.

5. Vera Brittain, *Testament of Youth* (New York: Seaview Books, 1933), 339;

Helen Zenna Smith (Evadne Price), *Not So Quiet . . . Stepdaughters of the War*, with afterword by Jane Marcus (1930; New York: Feminist Press, 1989), 95.

6. On changing standards of female beauty in America, see Lois W. Banner, *American Beauty* (New York: Knopf, 1983). On artistic representations of beauty in the 1920s, see Teresa A. Carbone et al., *Youth and Beauty: Art of the American Twenties* (New York: Brooklyn Museum, 2011). On bodybuilding as a post–WWI international phenomenon, see Ana Carden-Coyne, "From Pieces to Whole: The Sexualization of Muscles in Postwar Bodybuilding," in *Body Parts: Critical Explorations in Corporeality*, ed. Christopher E. Forth and Ivan Crozier (Lanham, MD: Lexington Books, 2005), 207-28, and, more generally, Ana Carden-Coyne, *Reconstructing the Body: Classicism, Modernism, and the First World War* (New York: Oxford University Press, 2009).

7. Umberto Eco, ed., *On Ugliness*, trans. Alastair McEwen (New York: Rizzoli, 2007), compiles a wide array of images and texts representing ugliness and grotesquerie through the ages and provides a multilingual bibliography on the topic. For an eloquent and moving meditation on ugliness, see Lucy Grealy's *Autobiography of a Face* (New York: Houghton Mifflin, 1994), the author's firsthand account of losing her jaw to childhood cancer and spending the rest of her life coping with the reactions of strangers—and, more importantly, those of her own estranged self—to the extreme abnormality of her face.

8. Béla Belázs, *Theory of the Film: Character and Growth of a New Art*, trans. Edith Bone (1952; rpt. New York: Dover, 1970), 286-87. The German feminist scholar Michaela Krützen takes exception to this claim, stating, "Garbo as an expression of protest against the existing social order seems absurd, especially in view of the feminist discussion about woman's suffering in the melodrama . . . a suffering which is to improve the woman morally." She also critiques Garbo idolatry by other prominent intellectuals Rudolph Arnheim, Siegfried Kracauer, and Roland Barthes; see Krützen, *The Most Beautiful Woman on the Screen: The Fabrication of the Star Greta Garbo* (New York: Peter Lang, 1992), 114-18, quotation on 115.

9. As quoted in Reginald Pound, *Gillies: Surgeon Extraordinary* (London: Michael Joseph, 1964), 34-35.

10. Harold D. Gillies, *The Development and Scope of Plastic Surgery*, the Charles H. Mayo lectures for 1934 (Chicago: Northwestern University Press, 1935), 2, quoted in Sander L. Gilman, *Making the Body Beautiful: A Cultural History of Aes-*

thetic Surgery (Princeton, NJ: Princeton University Press, 1999), 161; Ernest Hemingway, *A Moveable Feast* (New York: Scribner, 1964), 82. On *J'Accuse*, see Steven Philip Kramer and James Michael Welsh, *Abel Gance* (Boston: Twayne, 1978), 61–77, and Jay Winter, *Sites of Memory, Sites of Mourning: The Great War in European Cultural History* (Cambridge: Cambridge University Press, 1995), 15–18.

11. "Miracles of Surgery on Men Mutilated in War," *New York Times Magazine*, January 16, 1916, quoted in Elizabeth Haiken, *Venus Envy: A History of Cosmetic Surgery* (Baltimore: Johns Hopkins University Press, 1997), 32. André Breton defined surrealism in his first *Surrealist Manifesto*, published in Paris in 1924; see Breton, *Manifestoes of Surrealism*, trans. Richard Seaver and Helen Weaver (Ann Arbor: University of Michigan Press, 1972), although the term was introduced earlier by the poet Guillaume Apollinaire in the preface to his play *The Breasts of Tiresias* (1903, first performed in 1917). On surrealism and the *mutilés de guerre*, see Amy Lyford, *Surrealist Masculinities: Gender Anxiety and the Aesthetics of Post-World War I Reconstruction in France* (Berkeley and Los Angeles: University of California Press, 2007), and Sidra Stich, ed., *Anxious Visions: Surrealist Art* (Berkeley: University of California Art Museum, 1990).

12. Harold D. Gillies, *Plastic Surgery of the Face: Based on Selected Cases of War Injuries of the Face including Burns* (London: Frowde, Hodder and Stoughton, 1920).

13. Sir Harold Gillies and Ralph Millard, *The Principles and Art of Plastic Surgery*, 2 vols. (Boston: Little, Brown, 1957), vol. 1, 40. (On Gillies's surgical methods of "sex conversion," see vol. 2, 383–88.) On Spreckley in later life, see "BBC News: Quick Guide, Faces of Battle" (2007) http://news.bbc.co.uk/nol/shared/spl/hi/picture_gallery/07/magazine_faces_of_battle.

14. On Henry Tonks, see Emma Chambers, *Henry Tonks: Art and Surgery* (London: College Art Collections of University College London, 2002), and Chambers, "Fragmented Identities: Reading Subjectivity in Henry Tonks' Surgical Portraits," *Art History* 32, no. 3 (June 2009): 578–607. Tonks is fictionalized in Pat Barker's historical novel *Toby's Room* (New York: Doubleday, 2012). See also Suzannah Biernoff, "The Rhetoric of Disfigurement in First World War Britain," *Social History of Medicine* 24, no. 3 (December 2011): 666–85.

15. Ernst Friedrich, *War against War!* (1924), intro. Douglas Kellner and Publisher's Note by Catherine Hillenbrand (rpt; Seattle: Real Comet Press, 1987).

16. Friedrich, *War against War!*, 218.

17. See Douglas Kellner, "Introduction: Ernst Friedrich's Pacifistic Anarchism," in Friedrich, *War against War!*, 9–18. Kellner's introduction is available online at www.uta.edu/huma/illuminations/kell20.htm. See also Dora Apel, "Cultural Battlegrounds: Weimar Photographic Narratives of War," *New German Critique* 76, special issue on Weimar Visual Culture (Winter 1999): 49–84.

18. Belázs, *Theory of the Film*, 169. The quotation in the following paragraph is also from this page.

19. Susan Sontag, *Regarding the Pain of Others* (New York: Farrar, Straus and Giroux, 2003).

20. On the "return to order" in various artistic formats, see, for example, Kenneth Silver, *Esprit de Corps: The Art of the Parisian Avant-Garde and the First World War, 1914–1925* (Princeton, NJ: Princeton University Press, 1989); Silver et al., *Chaos & Classicism: Art in France, Italy, and Germany, 1918–1936* (New York: Guggenheim Museum, 2010); Romy Golan, *Modernity and Nostalgia: Art and Politics in France between the Wars* (New Haven, CT: Yale University Press, 1995); Winter, *Sites of Memory, Sites of Mourning*.

21. Courtney Graham Donnell, Susan S. Weininger, and Robert Cozzolino, *Ivan Albright*, ed. Susan F. Rossen (Chicago: Art Institute of Chicago, 1997); see plates 1–2, pages from Albright's medical sketchbook in 1918–19, and plate 17, with accompanying text about *Into the World There Came a Soul Called Ida*. See also the photograph, on 180, of Albright standing before the painting in his studio.

22. See Katherine Ott, David Serlin, and Stephen Mihm, eds., *Artificial Parts, Practical Lives: Modern Histories of Prosthetics* (New York: NYU Press, 2002), for cultural analyses of various modern prosthetic technologies.

23. F. Derwent Wood, "Masks for Facial Wounds," *Lancet* (June 1917): 949.

24. Ellen La Motte, *The Backwash of War: The Human Wreckage of the Battlefield as Witnessed by an American Hospital Nurse* (1916), in Margaret R. Higonnet, ed., *Nurses at the Front: Writing the Wounds of the Great War* (Boston: Northeastern University Press, 2001), 16. On the design "lag" between facial destruction and prosthetic reconstruction, see Katherine Feo, "Invisibility: Memory, Masks, and Masculinities in the Great War," *Journal of Design History* 20, no. 1 (Spring 2007): 17–27.

25. Anna Coleman Ladd in Padraic King, "How Wounded Soldiers Have Faced the World Again with 'Portrait Masks,'" *Saint Louis Post-Dispatch*, March

26, 1933, clipping in Ladd papers (Archives of American Art); T. S. Eliot, *The Waste Land* (1922), Section I, "The Burial of the Dead," lines 38–40; William Shakespeare, *Richard III*, Act 1, Scene 1: 18, 26.

26. See YouTube video, "Anna Coleman Ladd's Studio for Portrait Masks in Paris," www.youtube.com/watch?v = bCSzrUnie2E.

27. On Ladd, see Claudine Mitchell, "Facing Horror: Women's Work, Sculpting Practice, and the Great War," in *Work and the Image*, vol. 2, *Work in Modern Times: Visual Meditations and Social Processes*, ed. Valerie Mainz and Griselda Pollock (Burlington, VT: Ashgate, 2000), 33–53, quotation on 44; Caroline Alexander, "Faces of War," *Smithsonian Magazine* (February 2007): 72–80; Feo, "Invisibility"; and David M. Lubin, "Masks, Mutilation, and Modernity: Anna Coleman Ladd and the First World War," *Archives of American Art Journal* 47, nos. 3–4 (Fall 2008): 4–15.

28. Haiken, *Venus Envy*, 34–35.

29. Ralph Waldo Emerson, *Journals of Ralph Waldo Emerson, with Annotations*, vol. 6 (1841–1844), ed. Edward Waldo Emerson and Waldo Emerson Forbes (Boston: Houghton and Mifflin, 1909), 302; Zig Ziglar, *See You at the Top*, 25th anniversary edition (Gretna, LA: Pelican, 2000), 371; according to the dust jacket of Ziglar's book, this edition marks the sixty-fourth printing, with 1,671,000 copies in print.

30. Percy Marks, *The Plastic Age* (New York: Grosset & Dunlap, 1924). On Clara Bow, see David Stenn, *Clara Bow: Runnin' Wild* (New York: Doubleday, 1988).

31. John Gloag, *Plastics and Industrial Design* (London: George Allen & Unwin, 1945), 32, quoted in Brown, *Glamour in Six Dimensions*, 153. See Jeffrey L. Meikle, *American Plastic: A Cultural History* (New Brunswick, NJ: Rutgers University Press, 1995), and Robert Sklar, ed., *The Plastic Age (1917–1930)* (New York: George Braziller, 1970). Thanks to Joyce Tsai for her help with the early history of plastics.

32. Kathy Peiss, *Hope in a Jar: The Making of America's Beauty Culture* (New York: Metropolitan Books, 1988) and, for a view closer to the era in question, Gilbert Miller Vail, *A History of Cosmetics in America* (New York: Toilet Goods Association, 1947). See also Geoffrey Jones, *Beauty Imagined: A History of the Global Beauty Industry* (New York: Oxford University Press, 2010), and, on art and makeup, Melissa Hyde, "The '*Makeup*' of the Marquise: Boucher's Portrait of Pompadour at

Her Toilette," *Art Bulletin* 82, no. 3 (September 2000): 453–75; Marni Reva Kessler, *Sheer Presence: The Veil in Manet's Paris* (Minneapolis: University of Minnesota Press, 2006), chap. 2, "Making Up the Surface," 34–61; and Susan Sidlauskas, "Painting Skin: John Singer Sargent's *Madame X*," *American Art* 15, no. 3 (Autumn 2001): 8–33.

33. Helena Rubinstein, *My Life for Beauty* (New York: Simon and Schuster, 1966), 57–58; see also Lindy Woodhead, *War Paint: Madame Helena Rubinstein and Miss Elizabeth Arden: Their Lives, Their Times, Their Rivalry* (Hoboken, NJ: John Wiley, 2003).

34. On Rubinstein's collection of African masks, see Rubinstein, *My Life for Beauty*, 50–51, and Woodhead, *War Paint*, 15–17, 165–66, and 425; on Arden and her world, see Alfred Allan Lewis and Constance Woodworth, *Miss Elizabeth Arden* (New York: Coward, McCann & Geoghegan, 1972). On Elsie de Wolfe, see her autobiography, *As Is* (1935; New York: Arno, 1974); Jane S. Smith, *Elsie de Wolfe: A Life in the High Style* (New York: Athenaeum, 1982); Alfred Allan Lewis, *Ladies and Not-So-Gentle Women* (New York: Viking, 2000); and Penny Sparke's excellent analytical study, *Elsie de Wolfe: The Birth of Modern Interior Decoration* (New York: Acanthus Press, 2005).

35. See Oscar Wilde, "The Truth of Masks" (1891), "Pen, Pencil, and Poison: A Study in Green" (1891), and "Phrases and Philosophies for Uses of the Young" (1894), all in *The Artist as Critic: Critical Writings of Oscar Wilde*, ed. Richard Ellman (New York: Random House, 1968), quotations on 323, 389, and 433; Friedrich Nietzsche, *Beyond Good and Evil* (1886, section 40), trans. R. J. Hollingdale (New York: Penguin, 1973), 51.

36. Edward Gordon Craig, "A Note on Masks" (1910), in *Craig on Theatre*, ed. J. Michael Walton (London: Methuen, 1983), 21; on the avant-garde fascination with primitivism and violence in the years leading up to the First World War, see Modris Eksteins, *Rites of Spring: The Great War and the Birth of the Modern Age* (New York: Houghton Mifflin, 1989).

37. Walter Sorell, *The Other Face: The Mask in the Arts* (London: Thames and Hudson, 1973), 15.

38. Ernest Hemingway in Kiki (Alice Prin), *Kiki's Memoirs*, trans. Samuel Putnam, intro. Ernest Hemingway (New York: Black Manikin Press, 1930). See Woodhead, *War Paint*, 133 and 165; Billy Klüver, *Kiki's Paris: Artists and Lovers*,

1900–1930 (New York: Abrams, 1989). See also Whitney Chadwick, "Fetishizing Fashion/Fetishizing Culture: Man Ray's *Noire et blanche*," *Oxford Art Journal* 18, no. 2 (1995): 3–17, and Wendy A. Grossman and Steven Manford, "Unmasking Man Ray's *Noire et blanche*," *American Art* 20, no. 2 (2006): 134–47.

39. Palomar Alarcó, "Metaphorical Identities," in *The Mirror & The Mask: Portraiture in the Age of Picasso*, ed. Alarcó and Malcolm Warner, exhibition catalog (Madrid and Fort Worth: Museo Thyssen-Bornemisza and Kimbell Art Museum, 2007), 227.

40. Joan Riviere, "Womanliness as a Masquerade," *International Journal of Psychoanalysis* 10 (1929): 303–13. Reprinted in various collections, including Hendrik Marinus Ruttenbeek, ed., *Psychoanalysis and Female Sexuality* (New Haven, CT: College and University Press, 1966), 209–20.

41. A. Alvarez, *The Savage God: A Study of Suicide* (New York: Random House, 1972), 133; Sorell, *Other Face*, 209–10. Thanks to Scott Klein for bringing the *Inconnue* to my attention. See Paul Laurence Dunbar, "We Wear the Mask," in *Lyrics of Lowly Life* (New York: Dodd, Mead, 1896).

42. See Jones, *Beauty Imagined*, 136; Linda M. Scott, *Fresh Lipstick: Redressing Fashion and Feminism* (New York: Palgrave Macmillan, 2005), 222; and Meg Cohen Ragas, *Read My Lips: A Cultural History of Lipstick* (San Francisco: Chronicle Books, 1998).

43. Roland Barthes, "The Face of Garbo," in *Mythologies* (1957), trans. Annette Lavers (New York: Hill and Wang, 1972), 56–57; Rudolph Arnheim, *Film Essays and Criticism*, trans. Brenda Benthien (Madison: University of Wisconsin Press, 1997), 216.

44. Krützen, *Most Beautiful Woman on the Screen*, 69.

Figure 3. Bequest of Candace C. Stimson, 1944.

Figure 4. Digital image © 2014 Museum Associates/LACMA. Licensed by Art Resource, New York.

Figure 5. © Musées de la Ville de Rouen/C. Lancien et C. Loisel.

Figure 7. © Corbis.

Figure 10. © Aperture Foundation Inc., Paul Strand Archive.

Figure 11. © Aperture Foundation Inc., Paul Strand Archive.

Figure 12. From the journal *Camera Work*, 1903 (negative), 1906 (photogravure). Collection of Dorothy Norman, 1973. © 2014 The Estate of Edward Steichen/Artists Rights Society (ARS), New York.

Figure 13. © Aperture Foundation Inc., Paul Strand Archive.

Figure 17. Photo: Katherine Wetzel © Virginia Museum of Fine Arts.

Figure 18. Bequest of Edward Steichen under the direction of Joanna T. Steichen. Courtesy of George Eastman House, International Museum of Photography and Film. © 2014 The Estate of Edward Steichen/Artists Rights Society (ARS), New York.

Figure 19. Harvard Art Museums/Fogg Museum, George R. Nutter Fund, M10077. © 2014 Artists Rights Society (ARS), New York/VG Bild-Kunst, Bonn. Photo: Imaging Department © President and Fellows of Harvard College.

Figure 27. Courtesy of the Hunterian Museum at the Royal College of
 Surgeons of England.

Figure 29. Courtesy of the Estate of Francis Bacon. © The Estate of Francis
 Bacon. All rights reserved./DACS, London/ARS, NY, 2014.

Figure 30. Harvard Art Museums/Fogg Museum, Friends of the Fogg Art
 Museum Fund, M12398. © 2014 Artists Rights Society (ARS),
 New York/VG Bild-Kunst, Bonn. Photo: Imaging Department
 © President and Fellows of Harvard College.

Figure 31. University of Michigan Museum of Art, Museum Purchase 1935.20.
 Art © Estate of George Grosz/Licensed by VAGA, New York.

Figure 32. Photography © The Art Institute of Chicago.

Figure 36. Gift of James Thrall Soby. © Man Ray Trust/Artists Rights Society
 (ARS), New York/ADAGP, Paris 2014. Digital image © The Museum
 of Modern Art/Licensed by SCALA/Art Resource, NY.

Figure 37. Gift of Max McGraw, 1959.829. © 2014 Center for Creative
 Photography, Arizona Board of Regents/Artists Rights Society
 (ARS), New York.

Figure 38. Harvard Art Museums/Fogg Museum, Friends of the Fogg Art
 Museum Fund, M12404. © 2014 Artists Rights Society (ARS),
 New York/VG Bild-Kunst, Bonn. Photo: Imaging Department
 © President and Fellows of Harvard College.

Figure 39. Film grab.

Figure 40. Photofest, New York.

Figure 41. Photo: The Kobal Collection at Art Resource, New York.

beauty: and barbarity juxtapostition, 77–78; as business, 74; Miss America pageant, 49–50, 50*fig*.21; obsession with, 49–52; and patriotism, 17. *See also* cosmetic makeup

beauty revolution, and role of WWI, 85–86

Becker, Maurice, 20

Beethoven, Ludwig van, 80

Belázs, Béla, 51–52, 60, 93n8

Bellows, George: *"Blessed are the Peacemakers,"* 5, 5*fig*.2; *Cliff Dwellers*, 8, 9*fig*.4; as Hassam's opposite, 7–8; *New York*, 8

"Below the Battle" (Bourne), 29–30

Berlin postwar culture, 59, 61–62

Beyond Good and Evil (Nietzsche), 75

Billings, Warren, 13–14

Black and White (Noire et blanche) (Man Ray), 76*fig*.36, 77

blackface makeup, 80

"Blessed are the Peacemakers" (Bellows), 5, 5*fig*.2

Blind (Strand), 23–25, 23*fig*.11

body politic, 69, 70

bonds, war, 15–17, 33–35. *See also* posters, war

Bourne, Randolph, 29–30

Bow, Clara, 71

The Breasts of Tiresias (Appollinaire), 94n10

Breton, André, 94n10

Bryan, William Jennings, 2

Bull, Clarence Sinclair, 84*fig*.40

Burleson, Albert S., 1, 4

Camera Work (journal), 26

capitalism, 19–20, 24–26, 28, 31

cartoons, editorial, 2–5; Becker, Maurice, 2; Bellows, George, 5, 5*fig*.2; McCay,

Winsor, 2; Minor, Robert, 4, 4*fig*.1; Sloan, John, 3

celluloid, 71

censorship, 1, 4, 32, 60, 77

Central Park, 36–37

Central Powers, ix, 1, 36

Chafee, Zechariah, 90n28

Chaney, Lon, 83*fig*.39

Chaplin, Charlie, 33

Christy, Howard Chandler, 16–17, 16*fig*.9

Civilian Defense (Weston), 77–78, 78*fig*.37

Cliff Dwellers (Bellows), 8, 9*fig*.4

Cohan, George M., 17–18

Cole, Thomas, 35

Collier's New Photographic History of the World's War, 31–32

commercialization, 8, 19. *See also* advertising, commerical

Committee on Public Information ("Creel Committee"), 1

cosmetic makeup, 69, 72–74, 81, 86

cosmetic surgery, xi, 69–71, 81, 83–84, 86

Course of Empire: Destruction (Cole), 35

Craig, Gordon, 75

Creel, George, 1

"Creel Committee" (Committee on Public Information), 32

cubism, 59, 77–78

Dada, 76

Dance, Robert, 92n1

Daughters of the American Revolution, 19

Davis, Glyn, 26

deformities, 51–52, 61–62, 66–67

Delacroix, Eugene, 17

Dell, Floyd, 3, 89n21

democracy, 14, 30, 38

Demoiselles d'Avignon, Les (Picasso), 75

Deutscher Verein (German social club), 38

De Wolfe, Elsie, 74

radicalism, 1, 26, 28, 29–30, 64. *See also* Lyrical Left

Raemaekers, Louis, 15–16

realism, 37, 46, 62, 75

reconstructive surgery. *See* facial reconstructive surgery

recording industry, 17

recruitment posters, x, 15, 16, 32. *See also* posters, war

Red Cross Drive, May 1918 (Celebration Day) (Hassam), 10–11

Regarding the Pain of Others (Sontag), 61

Remember Belgium—Buy Bonds—Fourth Liberty Loan (Young), 15, 15*fig.*8

"Renascence" (Millay), 89n21

Richard III (Shakespeare), 69

Riviere, Joan, 80

Robertson, Bruce, 92n1

Rockwell, Norman, 18

Rogers, Ida, 64–65, 65*fig.*32, 83–84

Romantic era, 35

Roosevelt, Theodore, 3, 14

Rubinstein, Helena, x, 74

Rue Saint-Denis, fête du 30 juin 1878 (Monet), 10, 10*fig.*5

"Ruined Faces Club," 53, 54*fig.*22

Sargent, John Singer, 72

Schneck (artist), 16

The Scream (Munch), 44

self-alienation, 79. *See also* alienation

Self-Portrait (Bacon), 58–60, 59*fig.*29

self-portraits: *The Grieving Parents* (Kollwitz), 45; *Self-Portrait* (Bacon), 58–60, 59*fig.*29; *Self-Portrait with Hand to Forehead* (Kollwitz), 45, 45*fig.*19

Self-Portrait with Hand to Forehead (Kollwitz), 45*fig.*19

Sembach, Klaus-Jürgen, 42

sheet music covers, 17, 18

The Sinking of the "Lusitania" (McCay), 2

Sklar, Robert, 71

Sloan, John, 3, 36. See also *Masses* (magazine)

socialists, 3, 19

social reform, 23–25

Somme, Battle of the, 52

Sontag, Susan, 61

Sorell, Walter, 75, 80

Spreckley, William M., 53–54, 55*figs.*23–26

"The Star-Spangled Banner" (Key), 19

stasis/movement dynamic, 6, 10–11, 82

Steichen, Edward, 24*fig.*12, 41–47, 43*fig.*18, 62, 92n4

Stieglitz, Alfred, 24, 26, 30

Stimson, Alice, 14

Stimson, Henry L., 14, 17, 22, 26, 88n13

Strand, Paul: *Blind*, 23–25, 23*fig.*11; *Fifth Avenue, New York*, 21–23, 22*fig.*10; and Hassam comparison, 2–3, 30–31; *Manhatta* (film), 90n24; and Stieglitz, 24, 26, 30; *Wall Street*, 25–32, 25*fig.*13; and Ypres in ruins (*Collier's*) comparison, 31–32

Stravinsky, Igor, 75

St. Thomas's Episcopal Church, 7

Studio for Portrait Masks, 66–69. *See also* Ladd, Anna Coleman

suffering, psychological, 42–47, 51–52, 54, 85, 85*fig.*41, 93n8

Sun and Wind on the Roof (Sloan), 36

surrealism, 59, 76, 77–78, 94n10

Surrealist Manifesto (Breton), 94n10

Swedish Sphinx. *See* Garbo, Greta

Swinburne, Algernon Charles, 75

symbolism, 17, 21, 35

That Liberty Shall Not Perish from the Earth—Buy Liberty Bonds—Fourth Liberty Loan (Pennell), 34–35, 34*fig.*16